CELEBRITY AND RUNWAY
ST L LIFE

D0534674

WHO
WHAT
WEAR

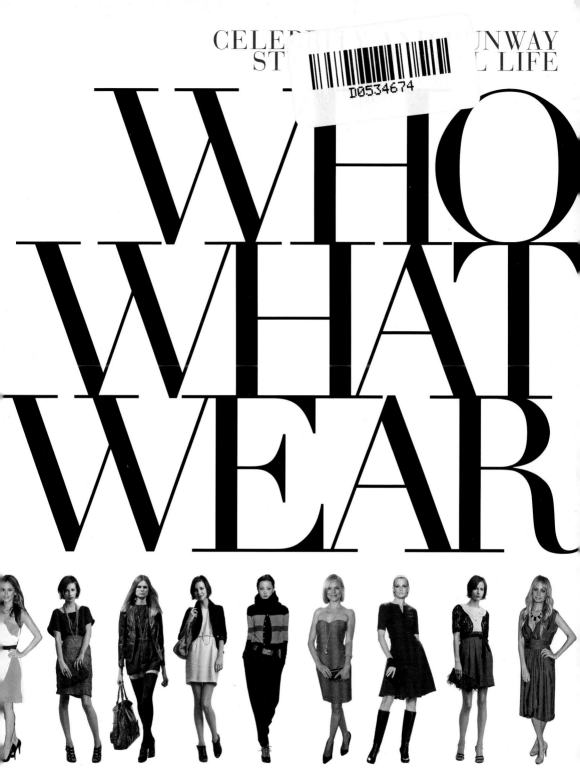

by hillary kerr and katherine power

Abrams Image, New York

WHO WHAT WEAR

contents

Introduction 6

1
Style by Inspiration 8

2
Not Every Trend Is for Every Body 20

3
Runway to Real Way 46

4
Investing in Trends 58

5
Cycle + Celeb = Trend 68

CELEBRITY AND RUNWAY
STYLE FOR REAL LIFE

WHO
WHAT
WEAR

by hillary kerr and katherine power

6

The Time-out Corner 80

7

In the Beauty Closet 88

8

What to Wear Where 96

9

Most Frequently Asked Style Questions 140

10

Staying Ahead from Home 148

Glossary 154

Photography Credits 156

Acknowledgments 157

Greetings and salutations, dear readers, and welcome to *Who What Wear: Celebrity and Runway Style for Real Life*. Some of you might know us from our day job—creating and producing the online celebrity fashion and beauty magazine WhoWhatWear.com—or we might be perfect strangers to you (in which case, it's very nice to make your acquaintance!). Either way, we're happy that you've picked up this little fashion guidebook and hope that you'll find it just as entertaining as it is enlightening!

There are usually two kinds of people who are curious about fashion: devotees and detractors. For the devotees, creating outfits and exploring new trends is a way of life, a much-needed outlet for self-expression and a source of joy and fulfillment. The detractors see fashion differently: they think it's all a ridiculous pageant, frustrating puzzle, or, even worse, a preening and pretentious exercise for the vain. However, regardless of whether you love it, hate it, or fall somewhere in between, one thing is certain: personal style is important.

The way you present yourself to the world and your ability to assemble fashionable outfits is crucial to success. Not to sound deeply superficial and psychotically anti-feminist—we're neither, we promise—but the plain fact of the matter is that you are judged, every single day, by the way you dress. Before you get to say a word or do a thing, your clothes are speaking for you, communicating strong messages to the outside world about your taste level, sense of self, and general acumen. Accordingly, it's incredibly important that you are aware of the latest trends and able to incorporate them into your everyday outfits in a thoughtful, stylish manner. When you're comfortable with fashion in this way, your wardrobe will convey that you are smart, sophisticated, and relevant—now, who doesn't want that?

Of course, we recognize that keeping up with zillions of swiftly shifting clothing, accessory, and beauty trends is a daunting task. In fact, we'll be the first to admit that trying the latest runway looks, emulating the best celebrity outfits, and figuring out the must-buys at your favorite stores can be difficult. But we also know that with a little guidance and a little bit of work, anyone can learn how to master all of the above and more!

Over the course of this guide, we'll share all the fashion secrets, tips, and tricks you need to ensure excellent personal style. Whether you want to learn how to make any trend work on any body type or what outfit you should wear for a variety of important social situations—we've got the answers for you. By the time you reach the glossary, you'll understand how to read the messages in a Prada show, why tastemakers like Kate Moss are so powerful, and when you should stop wearing a specific trend. Best of all: we're certain that by the time you're finished with this book, your fashion sensibilities will be super chic or at least significantly improved! (Hey, we're honest.)

—HILLARY & KATHERINE

Fashion is not something that exists in dresses only. Fashion is in the sky, in the street, fashion has to do with ideas, the way we live, what is happening.

COCO CHANEL

chapter

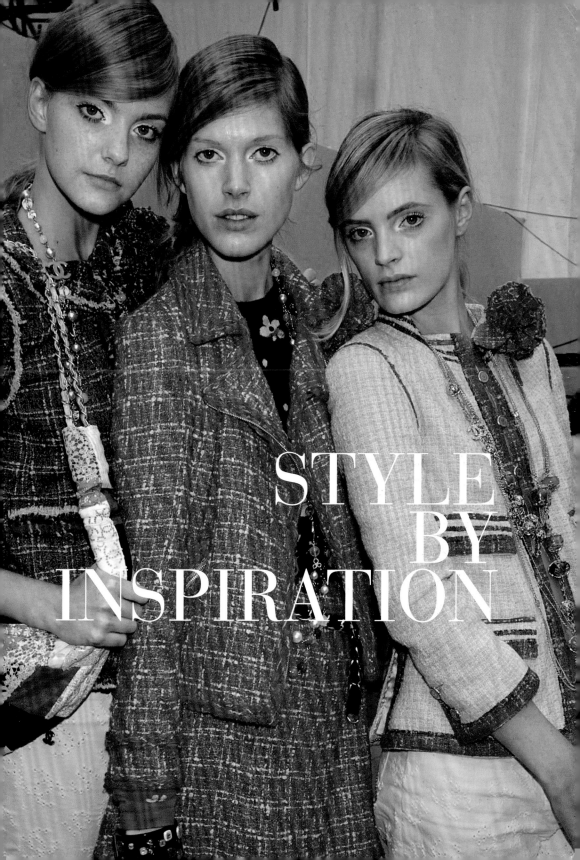

STYLE
BY
INSPIRATION

style by inspiration

Style is a tricky thing: everyone wants it, and
few have it. Creating your own personalized
version can be an expensive, time-consuming,
what-was-I-thinking?-filled process that goes on
for years. And if that wasn't enough, no mat-
ter how committed you are to the quest, great
results are not guaranteed! It's enough to make
anyone get annoyed, give up, and go buy a life-
time supply of uniforms, just to avoid having to
make any more fashion choices!

But let's assume, just for a moment, that you are up for a little self-discovery
style adventure. No matter if you're a total freshman who can't tell the dif-
ference between Marni and Mayle or the Chancellor of Fashion herself with
a closetful of next season's Balenciaga bags and vintage Philippe Chevallier
sunglasses, everyone could use a little help along the way. Just think of us as
your friendly tour guides—sans pleat-front khakis, of course—who will help
you learn how to become a better-dressed, more fashionable, style-savvy
version of yourself.

Now, before we hit the metaphorical trail and start searching for that rare and
covetable beastie, stylus personalus—otherwise known as personal style—let's
discuss our game plan. Regardless of your budget's size or the current state of
your closet, it's important to do your research. We're not talking about cram-
ming your brain full of fashion facts and stats—instead, we want you to focus
on the one simple thing that is the crux of every excellent outfit or admirable
look: inspiration.

SECRET STYLE WEAPON:
inspiration boards

At the Who What Wear office, we have an entire wall that's dedicated to inspiration. It's a constantly changing hodgepodge of our favorite runway images, celeb photos, editorials torn from our beloved overseas magazines (Paris *Vogue* in particular), fabric swatches, album covers, movie stills (we love Hitchcock), ad campaigns, black-and-white photography, and product shots of yummy coats, hats, handbags—whatever! The oversized collage might seem random and crazy, but it actually displays everything and everyone who inspires us and informs our work on a daily basis. The wall is a shrine to fashion and our favorite tastemakers—so it's is really quite fabulous looking and definitely adds an arty edge to the décor—but at the end of the day, it's just a really gigantic inspiration board.

People often pooh-pooh the inspiration board, as they associate it with the sort of scrapbook-style assemblages you make with your junior high pals, but we promise that it's actually a powerful tool to help discover your personal style. Plus, by creating a mood board, you'll be in fine company: most fashion insiders, including designers and editors, make new ones each season. The board lets these stylesetters channel their creative energy in a concentrated, playful way and provides them with a risk-free environment to try new things and experiment.

We highly encourage you to create your own version at home, though of course you don't need to dedicate a whole wall to your board. If you don't have enough room for a regular bulletin board, or fear that it might look too juvenile, just use the backside of your closet door, or even the inside of your bathroom cabinet, instead. Perfectionists take note: your board shouldn't be pre-planned or something that needs to reflect your taste in twenty years. It doesn't need to be cohesive or have a clear direction; it just needs to appeal to you in some way. Even if your instincts seem ridiculous—where would you even wear that avant-garde dress?—if an image appeals to you, grab it!

Just think of this as a simple snapshot of your taste at this particular moment in your life. You know how a mix tape (aw, we're dating ourselves) or playlist can conjure up a vibe or transport you to a specific moment? Your inspiration board should be similarly evocative and current.

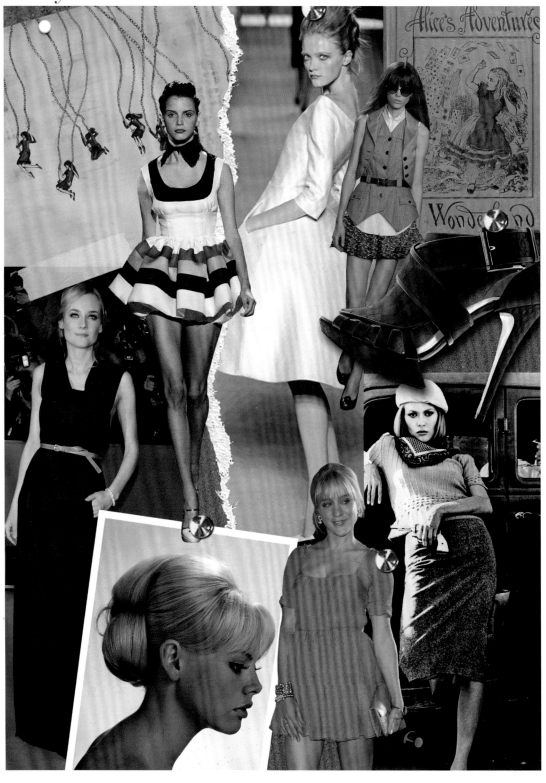

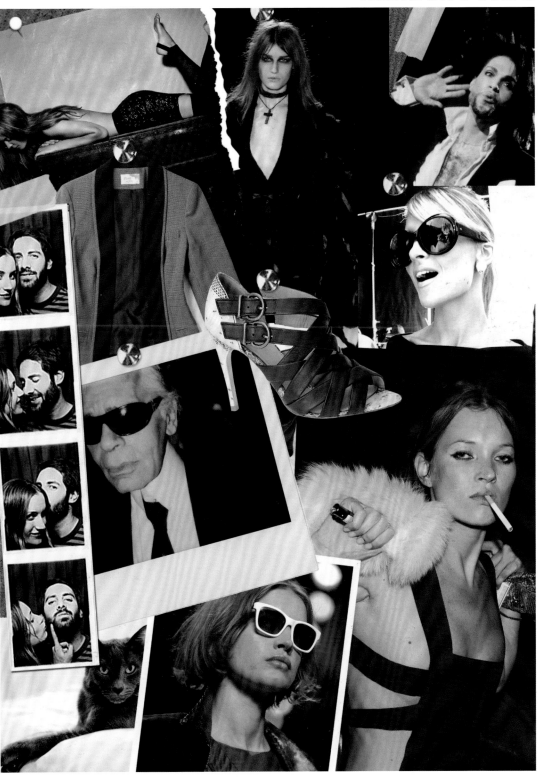

making your inspiration board

As for the actual nuts and bolts of assembling your inspiration board, there are only three things to keep in mind.

1
nothing's off limits

As we keep saying, inspiration can come from anything and anywhere, so keep your eyes peeled for things that delight you. **Fabrics, photos, magazines tears, and personal mementos are all great sources for mood board materials.**

2
follow your instincts

Let your subconscious take over and guide your mood board selections. You don't have to understand why you're pulling something for your mood board; you just have to find it interesting. If you **pick things that spark an immediate reaction**, you're going to have an honest and revealing board.

3
embrace fantasy

The point of creating a mood board is to delve deep into your desires, so **don't stop and analyze what you're selecting**. This is not the time to think about whether or not a particular silhouette would be flattering on your figure or if your accessories selections are in your budget, so just ignore those realities. You'll have plenty of time to be practical later!

interpreting your board

Once you've spent an afternoon—or an eon—creating your inspiration board, what the heck does it all mean? Sometimes it's easy to see a pattern. If you're drawn to platform peep-toe pumps, fishnets, peekaboo bangs and pin curls, tap pants, and pictures of sultry stars like Veronica Lake, your style is very 1940s femme fatale.

Of course, not every board will showcase such a "pure" look, which is certainly fine. Many of our favorite fashion icons blend a couple of different styles together to create their signature looks. If your board shows a seemingly incongruous mash-up of inspirations and you're unsure about what it all means, don't freak out. Here are a few examples of boards that hopefully will help you understand the deep mysteries of your style!

board examples

Strappy flat sandals, beaded accessories, fringe bags, vintage concert T-shirts, stills or posters from *Festival Express* and *Velvet Goldmine*, high-waisted jeans, over-sized aviators, pictures of Anita Pallenberg circa 1969, paisley prints, metallic fabrics.

1

defining themes:
Earthy hippie-chick standards, glammed up with sexy rock 'n' roll elements.

translation:
Bohemian Rocker (think: Kate Hudson, Sienna Miller)

on your board:
Motorcycle boots, skinny jeans, latex leggings, a picture of Joan Jett on stage in the late seventies, images from Alexander Wang's early runway shows, body-conscious dresses, bondage-influenced jewelry, little leather jackets.

defining themes:
Tomboy insouciance fused with sexy punk pieces.

2

translation:
Vicious Chic (think: Erin Wasson, Rihanna)

on your board:
Editorial shots from *Bazaar* in the forties (preferably by
Richard Avedon), slinky pencil skirts, strong-shouldered
blazers, leopard-print accessories, Joan Crawford in
Humoresque, spike heels, patent clutches, petite hats.

3

defining themes:
Forties classics toughened up with eighties
bombshell basics.

translation:
Hypercolor Heroine (think: Claudia Schiffer, Scarlett Johansson)

on your board:
Movie stills of Grace Kelly in *Rear Window* and Faye Dunaway
in *The Thomas Crown Affair*, perfectly worn-in Levi's 501 jeans,
ballet flats, crisp white button-downs, simple column or Grecian
dresses in solid colors, vintage brooches, ladylike clutches, racer-
back tanks, Michael Kors and Narciso Rodriguez runway images.

4

defining themes:
Timeless silhouettes energized with a few sporty pieces.

translation:
Classic Americana (think: Katie Holmes, Reese Witherspoon)

on your board:
Clunky spectacles, APC jackets, wedge heels, long-strap shoulder bags or briefcase totes, Margot Tenenbaum, high-waisted wide-leg jeans, quirky colors, the Lisbon sisters in *The Virgin Suicides*, paparazzi shots of Michelle Williams, milkmaid braids, penny loafers.

defining themes:
Laid-back seventies style mixed with a dash of geek chic and French flair.

translation:
Subversive Prepster (think: Kirsten Dunst, Chloe Sevigny)

on your board:
Super-pointy stiletto heels, Balmain and Givenchy runway images, skinny black pants, kohl eyeliner and bare lips, tuxedo jackets, Alaia bondage belts, textured ankle boots, unfussy hair, unconventional trousers, studded bags.

defining themes:
Cutting-edge designer pieces paired with sharp accessories for a dangerously cool look.

translation:
Euro Slick (think: Carine Roitfeld, Kate Moss)

a few of our favorite sources for inspiration

• european fashion magazines

We love all of the American glossies, but we find the most inspiration in their European versions, such as the UK's *Elle* and *Glamour*, Paris *Vogue*, and Italian *Vogue*. The European books just push the style envelope, so you'll see more innovative uses of fashion and cutting-edge photos.

• shelter magazines

If you follow fashion closely you'll notice that the textile industry's prints and patterns usually influence upcoming fashion trends, so interior design magazines like *Architectural Digest* and *Elle Décor* are excellent unexpected sources.

• old movies and pop culture

Most top designers are also pop culture fanatics and adore all the iconic old-Hollywood films, both of which are frequently referenced on the runway. Thanks to the web, you can easily check out archival images of these silver screen sirens or pull up photos of the designers' muses du jour.

• childhood memories

The idea of revisiting and reviewing your historical fashion choices is a scary thought for most people, we know. However, if enough time has gone by, old photos of yourself or your family can trigger a fantastic memory and, hopefully, a clothing, accessory, or beauty idea too! Even Marc Jacobs credits his childhood babysitter as one of his biggest inspirations.

• celebrity photos

Our favorite celebrity style icons—young or old, living or dead, A-list or obscure—are always rich resources for inspiration. As long as you love the way they look, anyone goes!

• runway images

If you're not familiar with Style.com, we suggest you get acquainted immediately. The website should be your go-to source for the complete archives of every major runway show and presentation over the past decade. You can check out how Oscar de la Renta suggests you wear his new length of cropped pants or how Diane von Furstenberg envisions women wearing their hair with her classic wrap dresses this season.

"Being a slightly miniature person, I had a hard time with the whole high-waisted trend. The way I made it work for me was to wear a high-waisted, wide-leg pant, instead of the skinny, tight version. It actually made me appear to be taller then I am."

RACHEL BILSON

chapter

trend (trĕnd) n.

1. The general direction in which something tends to move.

2. A general tendency or inclination.

3. Current style; vogue: the latest trend in fashion.

Okay, okay, we'll quit dorking out on grammar, but the dictionary does hammer home the following point: trends are suggestions. They're not mandates, not commandments, not rules, but—as many people tend to forget—they should be a starting point/cue/undercurrent in the overall tone of your personal style.

If you could order style at a bar, the recipe would look like the following:

STYLE COCKTAIL

Ingredients:
1 part fantasy
1 part reality
1 sprig of intuition

DIRECTIONS:
Mix equal parts fantasy and reality.
Stir, but do not shake.
Garnish with sprig of intuition. Imbibe!

Let's start by breaking down the style recipe: the fantasy is what you see on the runway and in fashion magazines, the reality is an honest appraisal of your frame and lifestyle, and the intuition is what personalizes your look. Intuition is how you incorporate trends into your wardrobe and make them your own. Now, don't be alarmed by the final ingredient in our style formula. Yes, some people naturally have a stronger sense of fashion intuition than others, but it can be learned and strengthened with ease (or patience, it all depends!).

Part of having fashion intuition is being able to mentally edit the overwhelming amount of trends out there. Each season, there are literally hundreds of new looks and styles shown on the runways, and clearly you can't follow all of them, nor should you! That said, always keep an eye out for classic comebacks, meaning those timeless pieces like wide-leg trousers or snug blazers, that phase in and out of popularity on a semi-regular basis.

Also, if you really connect with a certain look, you definitely should figure out a way to work it into your wardrobe. You just need to be judicious about what's really appropriate for your figure and lifestyle. The truth is, not every trend is for every body—appropriate choices must be made!—and that's okay. To figure out which looks work best for your frame, there are three options:

A. Hire a stylist for some professional fashion guidance *(the expensive way)*

B. Experiment with lots of outfits until you figure out a few great looks *(the difficult way)*

C. Try the two-step, fuss-free Who What Wear plan *(the best way, yay!)*

Let's assume you'd rather go our inexpensive, easy route.

Step 1: **First, you need to make an honest assessment of your height, weight, bust size, hip size, and body shape.** Is this fun? No, not really, but we promise it's helpful down the line. (And by down the line, we mean in this very chapter!) We can all be sorted into one of five typical physical types— slim (few curves, lean all over), curvy (bigger hips and bust, little waist), pear (smaller top, bigger bottom), cone (bigger top, smaller bottom), and athletic (muscular)—so figure that out first.

Step 2: **Once you're clear on your basic shape, all you have to do is pick your celebrity doppelganger and see what works on them!** Now, before you start saying to yourself, "Doppel what? Doppel who? Ted Doppel? The Doppler effect? Huh?" and write us off as two crazy ladies who accidentally started talking about physics theories in a style book, we'd like to explain our idea.

Instead of going it alone, unaided by any reference point besides your mirror, we suggest you find a celebrity who shares your basic body type (your physical double, aka doppelganger) and make note of their most flattering ensembles. Now, admittedly, celebs have killer bodies and most were physically blessed by the gorgeous-gene-and-fast-metabolism fairies. And yes, they've got discipline to spare, can afford fancy gym memberships or specialty classes, and patronize the world's top trainers and nutritionists, so of course they have near-flawless figures. However, despite their otherworldly physiques, these famously fit fe-males do have varied shapes and, just like the rest of us, they have some body parts they emphasize and others they camouflage.

Basically it comes down to this: make someone else do the hard work. After all, celebrities have access to the best clothes, accessories, and stylists that money can buy, so why shouldn't you benefit from their fashion solutions (and mis-takes)? Does this mean that you're doomed to a lifetime of Audrey Hepburn–inspired outfits, despite preferring bombshell styles, just because you're more beanpole than buxom? Nope! But wait a second; we're getting a little vague again, so how about we explain? Moving on to Style File Situations!

STYLE FILE SITUATION
THE CASE OF TUNIC TROUBLE

Your figure is tall, slender, and boyish. You also happen to love Mary-Kate Olsen's style, specifically a recent picture of her wearing a stellar tunic as a dress. How do you pull this look off?

Solution Mary-Kate is very, very diminutive. You, dear reader, are not, but that's not a problem. The way to resolve this issue is to think, What Would (my) Doppelganger Do? In this case, look to someone with a similar shape—perhaps the tall and lean Gwyneth Paltrow? She wears many Olsen-like outfits, but she tweaks these looks to make them appropriate for her body. She'd wear the tunic with a slim pair of cigarette jeans to highlight her enviable height and a cropped jacket to mix up the proportions. Applying the WWDD? Theory means you could still rock the fantastic item that caught your eye in the first place, just in a way that's figure flattering.

STYLE FILE SITUATION
THE CASE OF WAIST MANAGEMENT

You love dresses, especially the bohemian-inspired shapes that are voluminous and unstructured, like you've seen on Sienna Miller. However, you have some serious curves and are afraid that this dress style might look like maternity wear. Can you wear this silhouette?

Solution Dresses are the single most inclusive item of clothing around and, in our humble opinion, the easiest to wear. For someone with this shape, we suggest looking at how Scarlett Johansson tackles her wardrobe. She's clearly comfortable with emphasizing her retro curves, and you should be too. To avoid the dreaded "Are you expecting?" question, take that Sienna Miller–style shapeless sack and cinch it in with a substantially wide (at least two inches) belt. Word to the wise: cinching is best accomplished when the garment in question is made out of a thin fabric, like silk or rayon, so that you don't add unnecessary bulk to your frame.

STYLE FILE SITUATION
THE CASE OF TINY TORSO

You've adored Lauren Bacall–style trousers for ages and are thrilled that after eons of low-rise pants the high waist is back in style. You've seen how Katie Holmes sports this look, all tucked-in blouse and statement belt coolness. The catch? Katie's a tall girl and you are small enough to fit into her pocket. Can you wear this style without looking like your pants swallowed your torso?

Solution I bet you know what we're going to say, and yes, you're right. In this instance, why not turn to someone little and lovely—like Rachel Bilson. As you know by now, when it comes to high-waisted pants, Bilson prefers them to have a wide leg as well. But the real secret here is to pick a pair of bottoms that aren't specifically tagged as "high-waisted," because they will probably be out of proportion for a petite frame. Instead, look for a jean or trouser that merely has a classic or mid-rise (our go-to brands for this look include Seven for All Mankind, Levi's, and J Brand). We promise that by the time you've tucked in your shirt and looped a belt around your waist, you'll have the exact look you wanted.

STYLE FILE SITUATION
THE CASE OF PEG LEG

Every season you see Kate Moss wearing a different sort of short pant, a trouser style that never fails to taunt you because it's completely inappropriate for your body type. Whether we're talking about clam diggers, capris, carrot trousers, harem pants, banana slacks, or simply just cropped, you crave these abbreviated-hem bottoms like starlets want the spotlight. Sadly, you stay away from your pantalones of choice because you know you err on the pear side and fear that anything but full-length will cut off your legs in an unlovely way (not like there's a lovely way to do this). How can you ever try your Romeo look?

Solution There is a reason that Kate Moss is the world's most famous supermodel: she's got long legs and a super slim physique that allows her to wear any clothing trend she wants, including the difficult cropped-length trouser. But even girls who are a little more blessed in bottom department can attempted a short pant—albeit carefully. Take a cue from a luscious lovely like Beyonce and stick to ankle-grazing slacks that are only slightly cropped. Since shorter trousers chop up the length of your leg, we think it's important to go for a non-dainty heel, preferably a wedge, for elongation purposes. Pick a shoe that's bare on the top of your arch and stay away from ankle straps or gladiators. It's also a good idea to embrace a nude shoe, or one similar in color to your skin tone, as a contrasting color will emphasize where the hemline ends.

As for selecting a pant shape, we think a slightly loose/boyfriend style is going to be your best bet; anything tapered or too tight will highlight your body in the wrong way. Also, be sure to balance your tinier upper half by choosing the appropriate top. We suggest wearing a body-skimming, flowy blouse that hits just below your posterior (or bum, if you want to be less formal about things). Then add a fitted, cropped blazer over the shirt, as this will show off your little waist. Extra points if your jacket has puffed shoulders or epaulets, anything to add a little bulk to your dainty shoulders and put your entire body in perfect proportion!

STYLE FILE SITUATION
THE CASE OF TOO-TIGHT FRIGHT

After watching everyone from Cindy Crawford to Lindsay Lohan steal the spotlight with their tightly wrapped bandage dresses, you're finally feeling brave enough to try out the Robert Palmer–girl look. The only hitch in this otherwise "Simply Irresistible" plan? You're concerned that your belly looks fluffy, not flat. Can a girl with a touch of tummy get into a body-conscious frock?

Solution Super-skintight dresses (in the style of eighties heavyweight Hervé Léger, more recently popularized by Proenza Schouler, Christopher Kane, and The Row) are a red carpet staple and certainly a notice-me look. Contrary to popular assumption, these tightly wrapped frocks can actually hide a multitude of body sins—particularly a less-than-concave stomach. Just look for a bandage-style dress made from a heavy, slightly thick, extremely strong fabric to ensure that the stretchy material will suck in your softer spots and give you a desirable silhouette. If you don't feel wholly confident, take an outfit cue from the deliciously curvy Mandy Moore and simply slip a tuxedo jacket or slightly oversized boyfriend blazer over your body-conscious dress. You'll have a little coverage while still showing off an of-the-moment look.

If you're still not sure about the body-conscious dress, there's one additional pseudo-secret weapon you can try: shapewear! These super stretchy undergarments are all the rage with the red carpet regulars who have to wear tight clothes on a weekly basis. Celebs like Tyra Banks, Jessica Alba, Jennifer Aniston, and the aforementioned Ms. Lohan turn to brands like SPANX for figure-slimming shorts, panties, bodysuits, and slips to ensure they look picture perfect—and so can you! Try one of these seamless slimmers (every intimates line, from Hanes to Hanro, makes a version) under your body-conscious dress for the ultimate sleek physique.

DOPPELGANGER
DO'S AND DON'TS

If you're ever stumped about what to wear, just take a look at your Celebrity Doppelganger. Your CD gives you a cheat sheet on how to best dress for your body type.

Instead of those theoretical conversations you have in your closet ("Does this skirt really go with this top? Would this belt be too much with the earrings and hat?"), you can look to your CD for tried-and-true solutions for the biggest style conundrums! On that note, please read on for our reference guide for selecting your own celebrity doppelganger, plus a few great trends for each body type!

body
Short, slim

sample doppelgangers
Rachel Bilson, Sienna Miller, Nicole Richie

top trends to try
MINI DRESSES Worn with flats or heels (for night), you're the prime candidate for this coveted look.
WIDE-LEG TROUSERS OR JEANS Properly tailored pants like this will lengthen your legs.
WEDGES A pair of wedge sandals under your wide-legged jeans will create the illusion of a major growth-spurt.
SKINNY BELTS Go for a belt 2" wide or less, instead of one that takes up most of your middle—and makes you look shorter.

WWW WORDS OF WISDOM
Don't avoid the tailor. It doesn't matter how cute or expensive something is, if it doesn't fit, it's ugly.

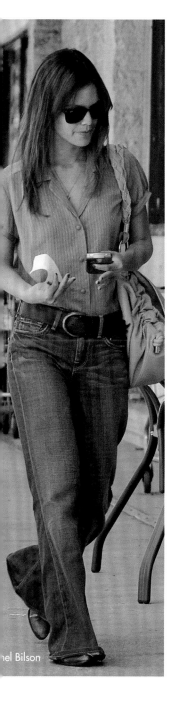

Rachel Bilson

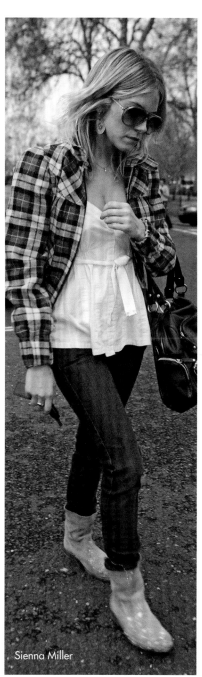

Sienna Miller

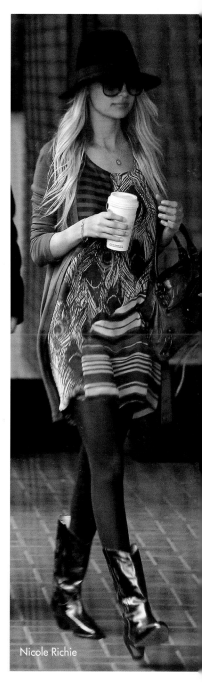

Nicole Richie

SHORT/SLIM

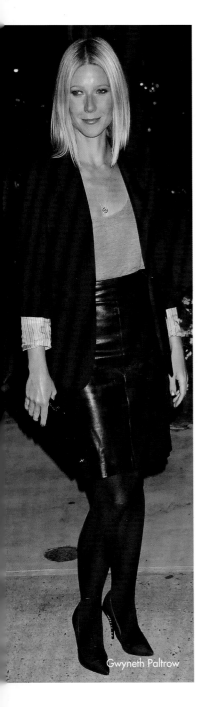

Gwyneth Paltrow

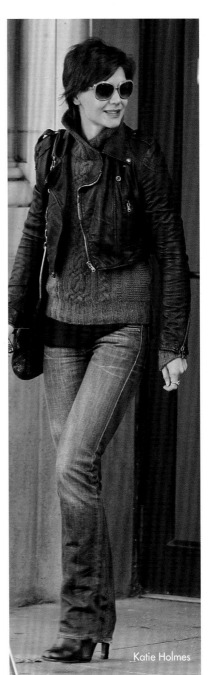

Katie Holmes

body
Tall, slim

sample doppelgangers
Gwyneth Paltrow, Katie Holmes

top trends to try

SKINNY JEANS OR CIGARETTE PANTS: Your legs are made for this style! Skinnies look great with either heels or ballet flats. Don't worry about the length of your pants because if they are a bit short, that works too.

TRENCH COATS: A classic cover-up that will work with any outfit. This coat can overwhelm a small frame but is ideal for your proportions.

HORIZONTAL-STRIPE TOPS: You have the body type that can afford to shorten your torso.

BIAS-CUT DRESSES: Pick a solid or a pretty floral (any tiny print will work), and it should hit you in all the right places.

TALL/SLIM

Scarlett Johansson

Kelly Osbourne

body
Short, curvy

sample doppelgangers
Scarlett Johansson, Kelly Osbourne

top trends to try
CORSET OR STATEMENT BELTS: A super-cincher will pull in your waist and accentuate your shape.

HIGH-WAISTED SKIRT: A solid-colored skirt like this will give you some height while showing your curves.

MAJOR PUMPS: Go for anything over 3" to give you that wiggle in your walk.

TUCKABLE TOPS: Voluminous shirts are the antichrist for petite hourglass types, so tuck that top in!

SHORT/CURVY

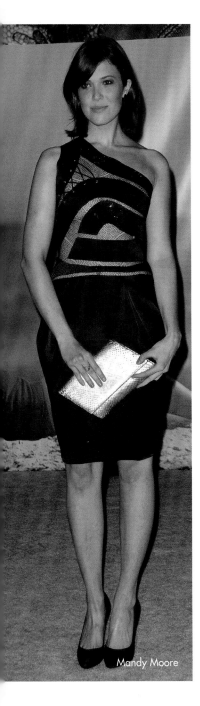

Mandy Moore

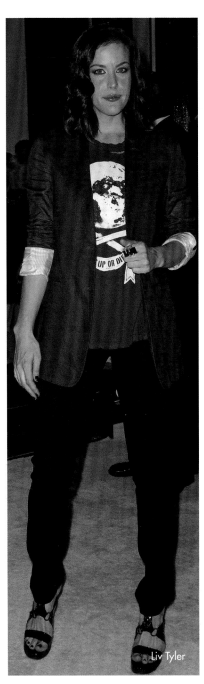

Liv Tyler

body
Tall, curvy

sample doppelgangers
Mandy Moore, Liv Tyler

top trends to try
BLAZERS: A fitted, well-tailored, single-breasted blazer will streamline your curves.

WRAP DRESSES: Always a classic and easy way to look effortlessly polished — just make sure it fits properly in the bust area. Also, if you don't want to wear a solid color, stick to smaller graphic prints. A big pattern can be busy!

V-NECK SWEATERS: Outerwear with a v-neck or a scoop will slim while it shows off what you've got on top.

PENCIL SKIRTS: A slim skirt (either high-waisted or standard rise) with a tucked-in blouse is perennially feminine and modern—without showing too much skin.

TALL/CURVY

body
Pear-shaped (more downstairs)

sample doppelgangers
Jennifer Lopez, Mischa Barton

top trends to try
SHIRTDRESSES: Styles with top-emphasizing details, like breast pockets or epaulets, will put you in perfect proportion.

STRAIGHT-LEG JEANS: While you can wear skinny jeans with longer, layered tops, it's best to stick with non-tapered, straight-leg jeans. Look for a hem that's at least 14" around.

A-LINE SKIRTS OR DRESSES: This always-popular cut slims your hips while hinting at your curves. Stay away from busy prints or thick material and pick a simple fabric instead, as this will avoid adding any unwanted volume.

VESTS: Throw a menswear-inspired vest over a tighter top to balance your curves and highlight your waist.

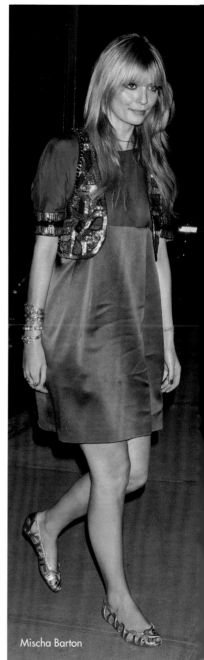

Jennifer Lopez

Mischa Barton

PEAR SHAPED

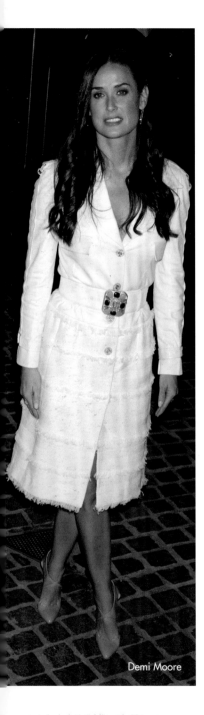

Demi Moore

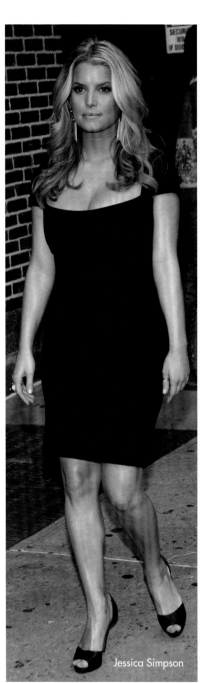

Jessica Simpson

body
Large bust (more upstairs)

sample doppelgangers
Demi Moore, Jessica Simpson

top trends to try

BELTED DRESSES AND OUTERWEAR: Whether it's over a lightweight summer dress or a winter coat, try adding a belt to cinch in your waist and create more of an hourglass shape.

SCOOP OR SQUARE-NECK TOPS: A high neckline will give the overall appearance of extra weight, so stick with a lower cut, but tasteful, neckline. Think: below the collarbone but above major cleavage.

LOW-RISE JEANS: If you try to wear high-waisted pants, all anyone sees is boobs and legs. Instead, lengthen your torso by wearing a great pair of mid or low-rise jeans.

LONG, WRAP CARDIGANS: A cardigan is always a good way to break up the upper body. The wrap aspect accommodates your figure, and the long length creates a cohesive line down your frame.

LARGE BUST

body
Athletic

sample doppelgangers
Jessica Biel, Cameron Diaz

top trends to try

RACERBACK TOPS AND DRESSES:
Where most women are less-than-toned (cough: flabby), you are fit and muscular. You should show this off, so why not try a racerback cut? Everyone will envy you.

CROPPED JACKETS: These jackets, especially double-breasted styles, look great on broad shoulders and a smaller chest. They create shape and show off your sleek torso.

BODY-CONSCIOUS DRESSES:
Athletic girls usually have noteworthy bums and flat stomachs. An Hervé Léger or Alaïa-inspired snug dress is just the ticket.

WIDE-LEG TROUSERS OR JEANS:
These perfectly tailored trousers will show off that toned behind and soften the look of potentially bulky leg muscles.

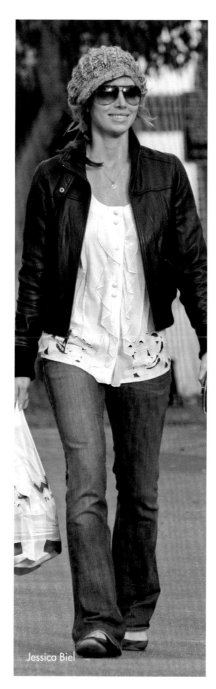

Jessica Biel

Cameron Diaz

ATHLETIC

I'D RATHER BE PAINTING MY NAILS:
THE BEAUTY FILES

Like rock stars and leather pants or celebrities and paparazzi, it's practically impossible to separate fashion and beauty. We figured that if we're addressing all these clothing concerns, we should also share some hair and makeup tricks, tips, and secrets. If you're going to look stunning from the neck down, we don't want you to look scary from the shoulders up!

Most women want to incorporate the latest hair/makeup trends in their beauty routines just as much as they want to work new styles into their wardrobes. They might ask themselves: **can I wear red lipstick even though I have olive skin? I've got a big chin, does that mean no bangs for me?** Again, this chapter is called *Not Every Trend Is for Every Body*, so there are going to be some exceptions, but generally speaking—yes, dear reader, we happily inform you the answer is yes!

The great thing about beauty trends is the simple fact that they're easy to integrate. There are fewer chances to make a major faux pas, simply due to a lack of real estate. After all, your head isn't nearly as big as your whole body, right? Not to mention, you don't have to stress about that blush or mascara being the wrong size or proportion. Plus, you're probably not going to suffer from buyers' remorse over an unused lip gloss or tub of conditioner since the initial investment isn't huge!

While beauty fads are more forgiving and economical than fashion trends, you need to be aware of the raw goods. This means assessing your skin tone, face shape, as well as hair length, texture, and current style. For example: as much as we'd love to have beautifully glowing tan skin, we are pale girls. Of course the universe made bronzer, but it's pretty ridiculous to attempt to make our alabaster skin turn into a deep golden complexion. Not to mention, then the rest of our bodies would look even more freakishly fair, and let's be honest—mismatched skin is just awkward. Fortunately you can achieve a flattering version of nearly any beauty look if you customize it. Think we're bluffing? We're not, and we'll break down a few of the top terrifying, yet timeless, beauty looks to prove our point.

WWW WORDS OF WISDOM
If you wear bright nail polish, keep it fresh and shiny by applying a coat of clear every couple of days until your next manicure.

BEAUTY STYLE SITUATION:
FRINGE ELEMENT

One of the most universally popular and easy-to-screw-up hair trends is statement bangs. Otherwise known as heavy fringe, this look has cycled back into focus every few years for several decades now (or centuries, if you think of the original poster girl for super bangs: Cleopatra). So many style icons have worn this notable hairstyle and styled it well. Just check out Bettie Page's look in the fifties, Jane Birkin in the sixties, Debbie Harry in the seventies, Michelle Pheiffer in the eighties in *Scarface*, not to mention hordes of other trendsetters. Even your authors have worn this look!

Now, we're not suggesting that this exact version of bangs will look good on everyone, but as with fashion trends, there's always a way to adapt a style to make it complementary. And while many of you may internally freak out if we ask you to envision yourself with the big bangs mentioned above, we'll show you that they're more universally flattering than it might seem at first glance.

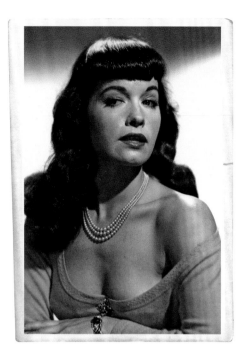

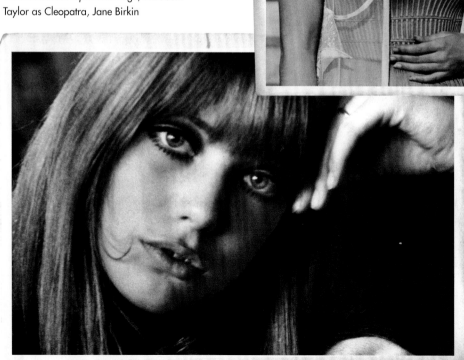

Clockwise from top: Bettie Page, Elizabeth Taylor as Cleopatra, Jane Birkin

FIRST THINGS FIRST: COMMITMENT AND COWLICKS

If you're at all considering cutting bangs, we feel you must dedicate or commit a certain amount of your hair real estate to get the best version of the look. Generally speaking, you need to cut at least 2" back into your hairline from your forehead. Anything less and you'll have a super wispy bang that will come off looking like *Beverly Hills 90210*'s Kelly Taylor circa the high school years—not so cute.

You also should suss out your cowlick situation. If you have a cowlick in the very middle of your hairline (think: directly above your nose), bangs are going to be an extremely risky choice. You're going to have to cut a very thick bang to create enough weight to have the hair hang down properly. Even then, you'll constantly have to straighten, blow dry, and pull on said bangs all day to keep them in place. If you have a cowlick only on one side of your hairline, try longer, angled bangs where your hair naturally separates at the cowlick, instead of blunt-cut classic bangs.

As we're all aware, foreheads come in many different sizes, which we like to divide into categories: twohead, fourhead, and fivehead.

small foreheads

TIPS FOR TWOHEADS

If you're working with a twohead, meaning a smaller forehead of about 2", we suggest looking into the above-mentioned, super heavy, strong bang à la Jane Birkin. These deep bangs, which should start 4" or 5" back from your hairline, will make your small forehead look proportionate to the rest of your face.

medium foreheads

TIPS FOR FOURHEADS

People with actual foreheads (about four inches high) have the most options overall. Depending on your face shape and hair—we'll get into this later—you can wear lots of different styles: deep bangs, sideswept bangs, or flapper bangs.

big foreheads

TIPS FOR FIVEHEADS

Now, if you have a fivehead, your best bet is a sideswept set of bangs, which will camouflage the great expanse of skin between your brows and your hairline. The great thing about this style is that it's flattering on most face shapes.

TIPS FOR COMMITMENT-PHOBES
Unlike marriage or buying Manolo Blahnik shoes, you don't actually have to make a serious commitment to get bangs. You can buy or custom-make clip-on hair pieces that will give you instant, scissor-free fringe! Otherwise, we suggest a sideswept bang, as this style grows out quickly and easily.

BEAUTY STYLE SITUATION:
READ MY {RED} LIPS

Red lips are another beauty trend that many women find oddly frustrating and frightening. So many ladies seem to think that they should intuitively understand what shade of red works for them. If they don't know, it feels too overwhelming to figure it out, so they skip it all together. That said, we think it's a crucial look to have in your beauty arsenal. After all, if it was good enough for Veronica Lake, Marilyn Monroe, and Elizabeth Taylor, it's good enough for you.

If that's not reason enough, consider the fact that red lips are a fashion industry favorite and appear on the runways nearly every single season. While the exact hue and texture changes, this trend has some serious longevity, so it's definitely worth investing in an excellent tube. Plus, this look is now considered acceptable at all times. Back in the old days, red lips were only worn in certain seasons (fall, winter) and times (at night). This, dear readers, is no more. Red lips look just as appropriate and fresh in the spring with light garments as they do in fall with more sumptuous pieces. A lightly pigmented, slightly matte formula is great for the day, while super-shiny scarlet gloss and deep-ruby lipstick are best for post-cocktail hour occasions.

FIRST THINGS FIRST: COLOR GUIDE

There are three kinds of red lipstick—true red, orange red, and blue red. Figuring out which one is for you only takes a minute and a mirror. Don't worry about the color of your hair or the color of your eyes. The only thing that's truly important is to determine the undertone of your skin: neutral, yellow, or pink. If you have neutral undertones, you should try true reds, yellow/olive undertones look good in warm orange-brown reds (fire engine), and ladies with pink undertones should go for cool blue-reds (cherry).

That said, there are a few all-purpose warriors in the red lipstick department. While it would be a lie to say that these shades look good on everyone, we feel confident in saying they look good on most. Our top three easy gliders are as follows:

1 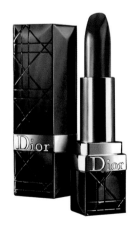 Dior Rouge Dior Replenishing Lipcolor Red Premiere

2 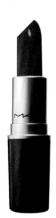 MAC Lipstick Russian Red

3 Lipstick Queen Red Sinner

TIPS FOR RED LIPS

We also have a couple of secret tricks for making sure that our lipstick application stays precise. First of all, it's always quite helpful to have a neutral lip liner like MAC's oh-so-loved Lip Pencil in Spice on hand. Use it on your entire mouth before applying whatever shade of red tickles your fancy, paying particular attention to the edge of your lips. The liner works like an electronic dog fence—it keeps things where you want them—without anyone else being the wiser. If you loathe lip liner, instead use your foundation brush and a smidge of concealer to clean up any extraneous red. Or you can use a makeup remover pen to keep your color in check.

Finally, we must address your fangs. Whatever shade of red you choose, please make sure that you whiten your teeth first. If your teeth look a little dingy, red lipstick will only accentuate this, and certainly no one wants to draw attention to their yellow teeth—the horrors!

orange-reds

YELLOW UNDERTONES

DEPARTMENT STORE: NARS Heat Wave; NARS Shanghai Express; Vincent Longo Fore-Plush; Guerlain KissKiss Lipstick Red Strass 521; Prescriptives Classic Red; MAC Chili; MAC Fresh Moroccan; Sephora Lip Attitude Chic Ruby

DRUGSTORE: L'Oreal Colour Riche Lipcolour Volcanic; CoverGirl TruShine Lip Color Fire Shine; Maybelline Moisture Extreme Midnight Red; Maybelline Superstay Lipcolor Cherry and Wine

blue-reds

PINK UNDERTONES

DEPARTMENT STORE: NARS Scarlet Empress; Laura Mercier Seduction; Smashbox Stunning; Vincent Longo Dakota Red; Sephora Lip Attitude Chic Class Red 14; MAC Russian Red; Prescriptives Racecar Red; Yves Saint Laurent Pure Lipstick Star Red; Chanel Shanghai Red

DRUGSTORE: L'Oreal Colour Riche Lipcolour Sunset Red and Red Rhapsody; CoverGirl IncrediFULL Lipcolor Ruby Rush; Maybelline Superstay Lipcolor Raspberry and Ruby; Maybelline Volume XL Seduction Full Bodied Wine

true reds

NEUTRAL UNDERTONES

DEPARTMENT STORE: NARS Fire Down Below; NARS Red Lizard; Smashbox Legendary; Sephora 94; Guerlain KissKiss Lipstick Insolence De Rouge 522; Yves Saint Laurent Rouge Pur #13, ck Calvin Klein 142 Eros; Opium Red; MAC Ruby Woo

DRUGSTORE: Max Factor Vivid Impact Ms. Right Now and Ms. Right; L'Oreal Colour Riche Lipcolour British Red and Drumbeat Red; CoverGirl TruShine Lip Color Valentine Shine; Maybelline Moisture Extreme Royal Red; Maybelline Mineral Power Lipcolor Ruby

BEAUTY STYLE SITUATION:
GET IN LINE

Another beauty trend that seems to freak the bejesus
out of many otherwise able women is eyeliner. Maybe
there was an "incident" involving an overly sharp-
ened pencil, maybe it's a fear of incorrectly applying
the product, maybe their mommas told them that
liner looks "fast" (like Sandy at the end of *Grease*).
Whatever the reason, we've got some tips that will get
you to test the waters.

FIRST THINGS FIRST:
GET EQUIPPED

There are various formulations for eyeliner—pencil, liquid, gel, cream,
cake—so just use whatever you feel comfortable handling. Soft pencils are
a great option for beginners because of their super-smooth glide capabili-
ties. If you have a steady hand, try a liquid liner (products with a felt tip
are the easiest to use). If you're handy with a little brush, you might like
a gel/cream/cake liner. Personally, we prefer brushes because the longer
handles allow you to prop your elbow on the bathroom counter when
applying your liner of choice. Having a steady base to use as an armrest
results in superior line control!

While everyone can wear eyeliner, where you apply it makes all the
difference. Before we get into that, first we'd like to address a common
mistake. Many women (ourselves included) make the mistake of bee-
lining straight to the black eyeliner. Unfortunately, you should generally
avoid black unless you really know what you're doing—amateurs are
highly likely to end up with a harsh look. A better solution is to use dark
bronze or warm brown shades because they'll give your peepers the sort
of subtle velvety look that makes people stare at your eyes—not your
makeup. If you feel unable to go without a liner in the black family, try
a dark gray or charcoal shade, as they "read" much softer than ebony
shades. Now on to where to wear your liner!

tips for deep-set eyes

If you have deep-set eyes, you don't want to go for a bold, thick, all-over liner look, as this will make your eyes look super-small. Instead, only apply liner on the outside of the eye, starting above the center of the iris and extending to the far edge of the lash line. Dark products will also make the eye recede, so instead accent the deep-set eye with liner in soft, warm colors, like gold or copper. To further open up the eye, try a lash curler or curling mascara and add a hint of light-colored, slightly shimmery shadow to the lid.

APPLY: Gold, copper, or light brown eyeliner

AVOID: Heavy, thick, all-over eyeliner; dark colors

ADD: Lash-curling mascara and light-colored, shimmery shadow (to open the eye)

tips for small eyes

Think about what you do when you're trying to camouflage a body part, like your butt. You wear black to make it look smaller, right? This theory is equally true when it comes to your eyes; so if you've got little peepers, stay away from dark liner and shadow! As for placement, a good rule of thumb is to never start your liner before the center of the iris, as you want to emphasize the outside half of the eye. It's also important to avoid highly defined liner, as this draws attention to the eyes' size, or lack thereof—so get out that Q-tip and smudge, our small-eyed friends, smudge.

APPLY: Taupe, light gray, bronze eyeliner

AVOID: Highly defined liner

ADD: Smudging (softly blended lines look best)

tips for close-set eyes

If you have close-set eyes, use skin illuminators with your liner to create the illusion of space. Try a little of Dior's Skinflash Radiance Booster Pen in shadowy parts of your eyes—like between your tear duct and the bridge of your nose—because light-reflecting products will draw them apart. Never, ever, ever, get liner close to the tear ducts. Instead, draw a skinny line from the mid-to-outside edge of your iris to the far outer end of the lash line.

APPLY: Extra-thin eyeliner

AVOID: Inner-eye liner

ADD: Skin illuminators to shadowy areas near the nose (to draw eyes apart)

tips for wide-set eyes

We have no tips for you, other than pick up any major fashion magazine and look at the models. The fashion world loves those wide-set eyes like a beauty queen loves world peace. You, lady, are lucky. Envy aside, if you'd like to make your wide-set eyes look closer together, just do the opposite of the directions for close-set eyes. In other words, concentrate your liner closer to the tear duct, with less pigment on the outside edges.

APPLY: Any kind of eyeliner

AVOID: Nothing!

ADD: Liner close to the inner eye

ADDITIONAL TIPS

You might have noticed that we've not addressed how to apply eyeliner to the bottom eyelid (we're going to call this "lower liner" going forward). The reason for our previous neglect might have something to do with our fatal attraction to lower liner. See, we love lower liner, especially the kind that lines the inner rim of one's eyelid, but it's one of the most difficult looks to pull off. Per our discussion in the small eyes section, dark colors make everything seem tiny, and by lining the inner rim you might make your eyes look miniscule. However, like lying out without proper sunscreen, we still do it despite knowing the ill effects. Consider yourselves warned.

There are alternatives: think of them as the sunless tanner version of lower liner. Most eye shapes will look lovely with a hint of color drawn through the lower lashes, starting from the outside bottom edge of the eye. The line shouldn't extend all the way to the inner edge: a good stopping point is anywhere from the outside edge of the iris (just the outer quarter of the eye) to just below the pupil (the outer half of the eye). If your eyes are huge, you can even extend product from the outside edge of the eye to the inside edge of the iris (or three quarters of the eye).

Again, this should be a super-soft application of pigment to avoid a harsh look. One trick we like is to just gently rub the brush we've been applying our upper liner with along the lower lid. There's enough leftover product on the brush to impart some subtle color.

One last note: if you have the tendency to blink lots, rub your eyes constantly, or just hate it when your eye makeup moves, try a water-resistant or waterproof pencil. There are many newly updated formulas available now—products that glide on easily and stay put!—you're sure to adore one of them!

product picks

SOFT PENCILS: Chanel Le Crayon Kohl Intense Eye Pencil; MAC Eye Kohl Pencil; Rimmel Soft Kohl Kajal Eye Pencil; Jillian Dempsey for AVON Professional Kohl Eye Liner

LIQUID LINER PENS: CoverGirl Line Exact Liquid Liner Pen; Lorac Front of the Line Eyeliner; Lancome Artliner Precision Point Eyeliner; Giorgio Armani Liquid Eyeliner

GEL LINERS: Smashbox Jet Set Waterproof Eye Liner; Stila Smudge Pot; L'Oreal HIP Color Rich Cream Eyeliner

BEST BROWNS: MAC Eye Kohl Pencil Teddy or Costa Riche; Chanel Le Crayon Khol Intense Eye Pencil Ambre; Clinique Kohl Shaper for Eyes Black Coffee

SOFT BLACKS: Bobbi Brown Creamy Eye Pencil Smoke; Sephora Slim Eye Pencil Dark Grey; MAC Pearlglide Eye Liner Black Russian

WATER-RESISTANT WONDERS: Urban Decay 24/7 Glide-On Eye Pencil; MAC Powerpoint Eye Pencil

Fashion shows are based on a conceptual idea. The way that we see the piece on the runway is styled to project that ideal. The key to wearing a runway piece is to take it out of context. Make it your own by mixing it with old favorites or simple everyday basics.

ERIN WASSON

chapter

3

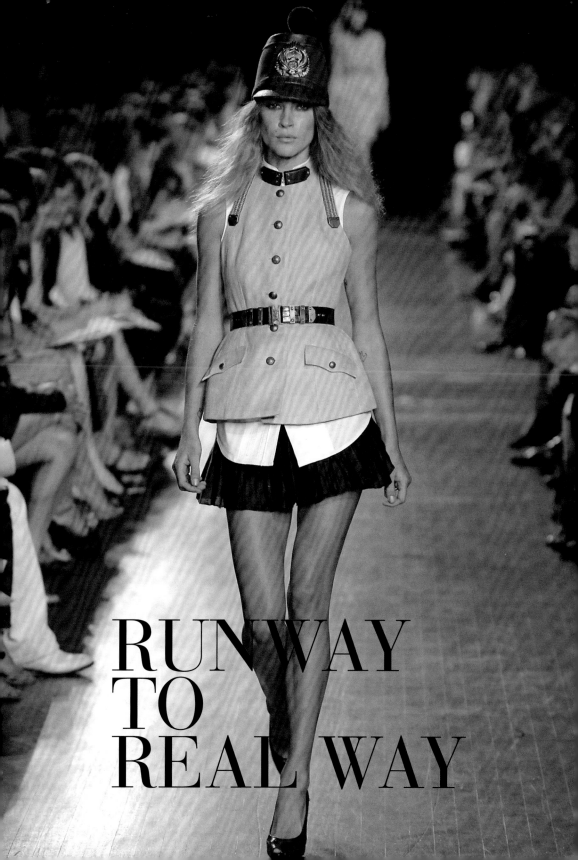

RUNWAY
TO
REAL WAY

runway to real way

There are countless crazy perks that come with working in the fashion industry—invites to the hottest parties, early access to the season's coolest clothes, baskets of beauty products—but without a doubt, the best part is attending runway shows. No matter how many times we've seen a particular designer or how many other presentations we've been to that day, the moment just before the show starts, we get shivers.

How could you not? First of all, you've got the world's top models stomping down the catwalk, just inches away. Sitting to your right: paparazzi favorites, ranging from well-dressed celebs to tastemakers to socialites. Sitting to your left: the industry's elite, including top editors from *Vogue* and *Elle*, buyers from all the biggest and best stores, and power publicists galore. You're listening to fantastic music and looking at incredible clothes—it's an unbelievable, over-the-top, ridiculously amazing scene!

Of course, as soon as the lights come up and the crowd races to the next show, our work begins. As fashion journalists and magazine editors, we field thousands of questions from readers and friends alike, wondering what the shows "mean" and whether or not they're important. The short answers are: everything and absolutely.

At the end of the day, it's important to remember that runway shows are actually very aptly named. They're not documentaries or nonfiction works of art, but "shows" that are meant to entertain, enlighten, and explain a point of view. A collection simply conveys the designer's vision and what he or she thinks people will want to wear in the upcoming months. It presents their ideas about what will be "on trend" for the season and how one should style their look, from hairdo to heels.

That said, a show is a concept—sometimes a very highbrow one—featuring outfits that are not usually approachable, accessible, or even appropriate for everyday life. The same holds true for the key fashion spreads you find in the well of magazines like *Vogue*, *Elle*, and *Harper's Bazaar*. If you've ever found yourself looking at either of these things (shows or spreads) and thought, "I'm not so sure those sky-high orange platforms would really be a good choice for grocery shopping at the Winn Dixie," or "Wow, if I wore my hair in a three-foot-high beehive, I'd look so stupid," you're probably right. That's why you have to read between the lines!

how to read the runway

Obviously, dear readers, we know that you know how to read (duh). However, we're talking about reading the runways and fashion editorials, which requires a somewhat different sort of skill set, one that we're happy to help you with. We want you to be fully fluent in the language of Fashion, to speak Fashion with a perfect accent and correct idioms, and to have such a complete comprehension of Fashion that you could get a job as an internationally sanctioned interpreter! You, yes, you!

Fashion-reading is actually quite intuitive: if you can observe the various looks and notice the key themes, then you will be able to translate even the most out-there outfits into something that works with your personal style.

We see that you're shaking your head in disbelief, giving us the stink eye, thinking that we're making it sound too easy, but we're really not. Shall we table this debate for a second and walk you through an example or two? Indeed!

BREAKING DOWN THE BASICS

Fashion editors and stylists sometimes act like decoding a crazy high-fashion look is some difficult and mysterious process, but it's really quite simple. Whenever we need to interpret the runway madness into the latest clothing trends and realistic outfits, we merely run through our Runway to Real Way checklist. Just by breaking down a collection into a few concrete and simple categories, you can turn what looked like an impossibly complicated ensemble into an easily attainable look! We'll walk you through a few examples and show you how to do it at home, but first, let's discuss the key classifications: color, fabrics, prints and patterns, accessories, and themes.

1
color

One of the easiest ways to reference a runway collection is to mimic the show's color palette, so start your own Runway to Real Way interpretation by noting the hues used. Were there lots of neutrals? Neons? Black? Pastels? Brights? Metallics? Muted colors? Primary colors? Shades of gray? Jot it down!

2
fabrics

Look at the fabrics the designer has chosen. Are most of the pieces made out of puffy tulle or thick tweed? Casual cotton or fancy satin? Remember to look for all the major materials, including: tweed, leather, silk, lace, sequins, spandex, velvet, felt, wool, linen, brocade, flannel, and, of course, denim.

3

prints & patterns

Sometimes, all you have to do to channel a runway look is to get a great piece (clothing item or accessory) in the "it" print or pattern. So check the collection and decide if your Real Way search includes hunting for animal prints, polka dots, stripes, plaid, art-inspired, floral, checks, or batik.

4

accessories

Check the outfits' accoutrement for more clues about how to translate the look. Then scout for pieces with similar styles, whether that includes a hat (bowler, top hat, newsboy cap, boater, fedora, beret, or beanie), belt (skinny, thick, corset, fabric; at the waist or below the waist; buckled or interlocking), jewelry (fine, costume, oversized, ethnic), handbag (clutches, frame bags, hobos, totes, top handles), shoes (boots, flats, pumps, platforms, wedges, sandals), or scarf (little, long, lightweight, oversized, circular, thick, sheer).

5

themes

Designers love to mine previous eras for fashion ideas, so try to identify if the collection references any important styles. A few recently popular influences include: punk, western, safari, bohemian, military, ballet, glam rock, flapper, and prairie, plus all the various historical time periods (medieval, Victorian, Edwardian, and the twenties through the eighties).

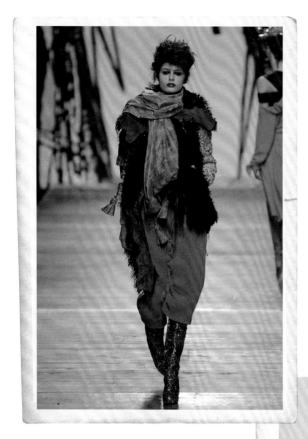

RUNWAY

REAL WAY

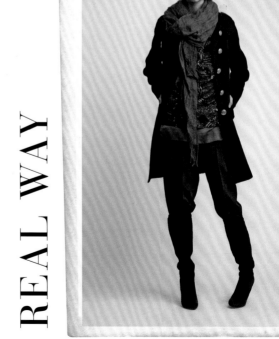

EXHIBIT A
VIVIENNE WESTWOOD

Now that you know what you should be looking for, let's work our way through an actual Runway to Real Way example. Starting with the mistress of heavily messaged fashion—Vivienne Westwood—let's examine an outfit from one of her past collections, using our checklist.

COLORS: *black, olive, charcoal, khaki, ochre*
Westwood chose no-fuss neutrals for the bulk of the collection, and this look is particularly is heavy on the utilitarian hues.

FABRICS: *nubby knits, thick wool, fur, heavy silk*
While the colors might not pop, the overall effect is still interesting, thanks to a mix of textures and fabrics.

PRINTS AND PATTERNS: *n/a*
It's all about solids, so we'll skip this category.

ACCESSORIES: *knee-high boots, oversized statement scarves*
The flair in this look comes courtesy of the accessories, so this is the area of the outfit where you can have a little fun and incorporate some slightly dramatic pieces.

THEMES: *savage chic meets military with glam touches*
The black animal pelt is very Cro-Magnon warrior, while the dusty olive britches have a militaristic air to them. But then the whole look is poshed up with Hollywood-style ruby-red lips and a glittery pair of Ziggy Stardust boots.

REAL WAY: There are literally millions of ways to re-create the look, but we decided to start with a dark pair of slouchy pants, and then, to get the effect of the cropped trousers seen on the runway, we tucked them inside a pair of knee-high suede boots.

As for the rest of the outfit, we looked for pieces that shared Westwood's neutral palette. Keeping the runway hues in mind, we selected a long-sleeved silky top that hit just below the hip and then layered a shorter, sequined tunic over it. The tunic brings in one of the required elements for this look—shine—in a practical way. (It's unlikely that you have sparkly boots in your closet, but most people can find a sequined top with ease.) Our finishing touches for this look: a military-inspired coat and two lightweight scarves, wrapped together for some additional heft. Voila! The Runway to Real Way look is complete!

WHAT YOU SEE (RUNWAY): black, brown, tan, charcoal, and olive tones; messy, roomy layers; oversized, Mongolian-style, sheepskin gilets; slouchy, army-green knit trousers; bedazzled charcoal boots; glossy red lips; puffy updos
WHAT YOU GET (REAL WAY): dark, slouchy pants; knee-high suede boots; long, silky top; shorter sequined tunic; military-inspired overcoat; neutral-colored lightweight scarves

EXHIBIT B
MICHAEL KORS

Even when a designer presents a high-concept, hugely wearable show, there's still much you can learn from examining the collection. Take, for example, the lovely ladylike looks that sauntered down Michael Kors' Fall 2008 runway. The all-American designer was infused with the spirit of a very specific time period and style—Madison Avenue in the early sixties—for a presentation that was posh and elegant. While going full-blown *Mad Men* chic à la Michael Kors might be a little retrorific for real life (not to mention costly), you can still borrow some ideas from the runway show to create your own version of the look, using our handy checklist to guide you!

COLORS: *tan, caramel, champagne, buff, wheat, grass green, and violet*
The color palette at Michael Kors was heavy on the natural nude hues, paired with pops of time period–appropriate bright greens and various shades of violet.

FABRICS: *rich cashmeres, traditional herringbone, cozy knits, touches of fur*
This is a sumptuous collection, full of luxurious natural fabrics that simply scream Upper East Side chic.

PRINTS AND PATTERNS: *a few floral prints, but they're not crucial for this look*
Kors primarily stuck to solids, though there were some uber-feminine frocks done up in sweetly romantic florals and a handful of animal print pieces.

ACCESSORIES: *fedoras, thick tortoiseshell glasses, slim belts, pointy stiletto pumps*
This collection was stuffed with wonderful retro accessories including traditional fedoras and ladylike essentials, like gloves and simple sexy heels.

THEMES: *early sixties working-girl chic*
The entire collection was a valentine to well-heeled Hitchcock heroines like Tippi Hedren and Eva Marie Saint. The clothing's classic clean lines and rich neutral color palette combines to form amazing ladylike looks!

REAL WAY: Since the overall silhouette was slim and inspired by the early sixties, we started the outfit with a snug sweater in a kelly green hue. The three-quarter sleeves are modern, while the modest neckline is a nod to the era's prim looks. We made sure that the sweater was made from a thin fabric, as the show was all about long, lean looks.

Next we chose a tailored pencil skirt in a Korsian shade of camel, tucked the sweater in, and added a skinny animal-print belt. Last, but not least, we found a pointy pair of nude stilettos (we love how they elongate the leg) and selected a traditional fedora to reference the runway's most important accessory!

WHAT YOU SEE (RUNWAY): tan, green, and violet tones; narrow, knee-length dresses; pencil skirts; slim sweaters, double-breasted coats; fur collars and coats; leopard prints and floral patterns; belts; pointy stilettos; frame bags
WHAT YOU GET (REAL WAY): tailored camel skirt; kelly green mock turtleneck sweater with cropped sleeves; skinny animal-print belt; tortoiseshell glasses; nude pointy pumps; classic tan fedora

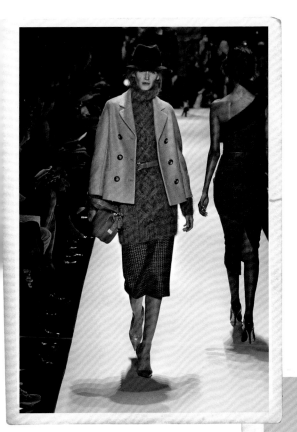

RUNWAY

REAL WAY

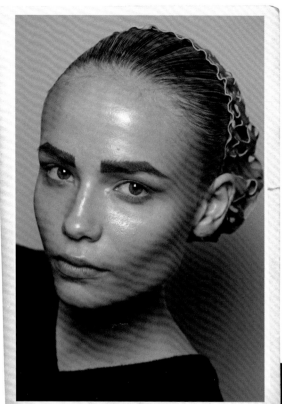

RUNWAY

REAL WAY

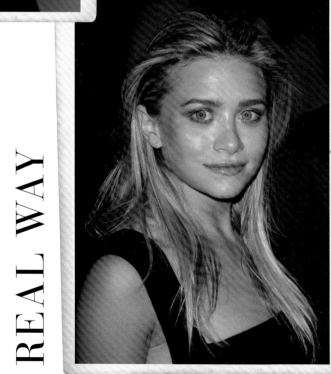

EXHIBIT C
PRADA

A great example of a seemingly impossible runway beauty look came courtesy of one of Miuccia Prada's fall runway shows. Prada is known for their ahead-of-the-curve hair and makeup trends—which can run the gamut from glittery gold eye shadow to turbaned-do's—so we paid careful attention to this statement style.

The models showed off lush, large, overly luxurious eyebrows, which were exaggerated and extended with heavy brown pencil, then brushed straight up, as if to salute the sky. The rest of the beauty look was totally plain—hair in unfussy buns and bare skin, lips, and cheeks—almost Amish in its austerity. What was Miuccia (Ms. Prada to you, if you're nasty) trying to tell us? We didn't ask her—our Italian is quite *porero*—but we have a hunch that her reasoning might sound something like this:

"Ciao amici! Remember when you plucked your eyebrows into super-thin squiggles back in 1993? I know, I know, you'd seen Drew Barrymore in those Guess? ads and went a little nuts with the tweezers-it happens. She looked fantastico, but times have changed. Now it's time to grow back those brows, so break out the Rogaine and brown pencils!" xoxo Miuccia

See, dear readers, the dramatic beauty message can be distilled into one simple suggestion: try full brows. If you need an example of what the Real Way version of this Runway style looks like just take a look at Ashley Olsen. The well-dressed mini mogul has a beautifully full and natural-looking pair that are realistic, not ridiculous.

WHAT YOU SEE: Big bold brows; exaggerated arches; black paint or tape-covered eyebrows
WHAT YOU GET: Let your skinny brows grow back into a more natural, full shape, as seen on Ashley Olsen.

At the end of the day, the runway look simply has to inspire you—there's no formal level of incorporation required. Feel free to take a single subtle element from the collection or multiple aspects—either way is perfectly acceptable. Once you begin thinking in this way (considering the colors, shapes, and other crucial aspects), you'll find that shopping becomes a breeze. Your brain will train itself to seek out on-trend pieces, so you won't have to worry if you're gravitating toward something passé!

> **"** *[Every woman should invest in] a good strand of pearls. The length depends on the lady's size and style, either 16" or 36".* **"**
>
> KENNETH JAY LANE

chapter

4

INVESTING IN TRENDS

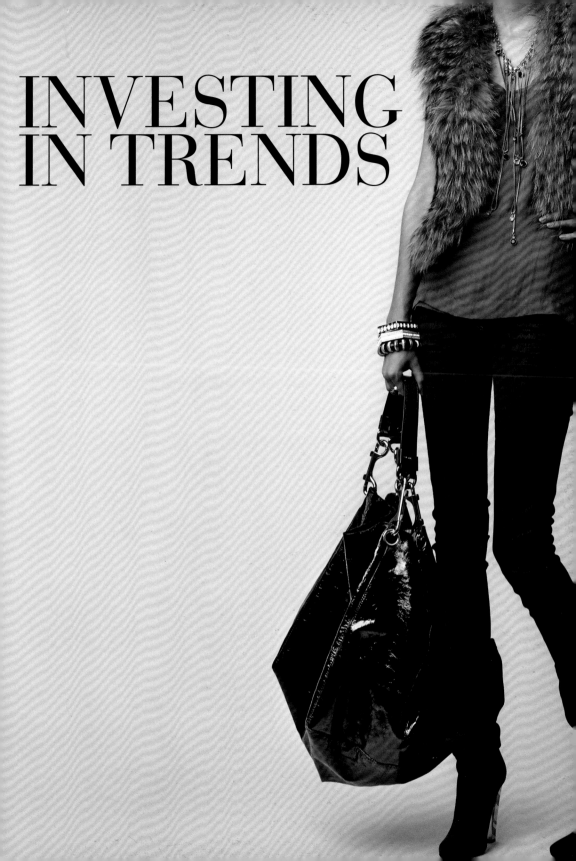

investing in trends

One thing we know for sure is that amazing personal style isn't about having fancy designer clothes or only dressing in the latest looks, it's about the way you put outfits together. You could have all the money in the world, access to the most important fashion houses, and a team of stylists on your payroll, but that still doesn't guarantee that you'll look great. All in all, despite how snooty and clubby the fashion scene can be, style is a meritocracy. No matter how high or low your background and budget may be, if you have a true sense of style, you can be fashionable.

Fortunately for those of us not naturally gifted with exemplary taste, style can be learned. After conducting much research, we discovered that realizing your best-dressed self requires mastering two things:

1. Build a strong wardrobe foundation

2. Add personal flair by mixing in current, trendy pieces

PRICE PER WEAR

The cost of an item divided by how many times you wear it. It's a way of justifying splurging on a pricier piece (if you're going to get tons of use out of it). For example: if you spend $400 on a pair of designer shoes you love, but you end up wearing them four times a week, they have a price per wear cost of $1.92 [4 times a week x 52 weeks a year = 208. $400 divided by 208 = $1.92] Obviously this is a better choice than spending $200 on a pair of shoes that you're not crazy about and only wear infrequently, if ever.

what trendsetters wear

The trendsetters who truly inspire us are highly skilled at creating mixed outfits. Each season, they recycle their older favorites (Step 1: use strong core pieces) and combine them with new trend-infused items to create highly individualistic ensembles that show off their personal taste (Step 2: mix in current, trendy items).

Take Kate Moss, for example. The woman is known for adeptly weaving together different designers, seasons, and price points into one artfully cool outfit. As a supermodel and major fashion influencer, Moss naturally has the access and means to wear whatever she wants. Yet despite these limitless options, for the past two years she has faithfully worn her favorite gray Siwy skinnies (the Hannah style) on a weekly basis. The jeans are not cheap, but she wears them so much that they've ended up having a very reasonable price per wear. She subsidizes this beloved staple with chic bargain finds from Topshop or thrifty vintage accents from London's Portobello Market, and she finishes the whole thing off with an of-the-moment handbag or it-list leather jacket.

In other words, the formula for Moss's marvelous style is simple:

Basics + Thrifty Thrills + Upscale Splurge = Instant Style

The combination of high street and high fashion is part of the reason why the world loves the way Moss dresses—it seems accessible. Happily her methods are easy enough to emulate: all it requires is a little bit of planning and work.

SAVE VS. SPLURGE

Assuming that you're creating your closet from scratch or at least giving it a huge overhaul, we recommend that you start by buying the absolute best basics at whatever price point you can afford. Your goal is to find timeless silhouettes—not super-short, tight, or cleavage-baring styles—in neutral colors and make sure that everything is impeccably tailored. When your wardrobe is flush with these indispensables, then it's time to add a little flair!

One of our favorite tricks to spruce up a classic base is to indulge in of-the-moment outerwear—whether it's a lightweight cardigan in the spring or a wool coat in the fall—to instantly refresh and upgrade your look. Seriously, even if you're wearing a simple T-shirt, skinny jeans, and pencil-heeled pair of pumps that are from several seasons ago, if you throw on a really great jacket, you'll instantly look totally cute and current! You don't need to buy tons of coats and jackets, just decide which of the season's standout shapes you like best and splurge on one or two, depending on what you can afford. The same holds true for bags and shoes: it's better to have a few amazing pieces, rather than lots of shoddy styles.

If you really want to take it a step further and go for a super-stylish look, accessorize with abandon (but in a budget-friendly way). This means picking up and incorporating a few inexpensive trendy components, like a vintage fur vest or an armful of India-inspired gold bracelets, into your outfit. This mix of classic, luxe, and thrifty makes for memorable personal style!

WWW WORDS OF WISDOM
Never throw away designer clothes from the big fashion houses. They will always come back in style.

THE BASICS
TIMELESS ESSENTIALS

OUTERWEAR: *blazers; peacoats; trenches*
Whether it's a traditional military-style peacoat, preppy little blazer, or Holly Golightly–inspired trench coat, you should save up for one of these classics. A well-made jacket or coat is an important investment for two reasons: it ensures that you'll make a good impression (after all, it's the first thing people see) and, with proper care, a single smart buy can last a lifetime.

TOPS: *button-ups (solid or striped); T-shirts; cashmere sweaters; slim black turtlenecks; dressy tanks or shell tops*
The crucial characteristic to look for in an investment-worthy classic shirt is adaptability. If you can envision yourself wearing the top in question to a variety of events and situations—say, to work and on the weekends—go ahead and upgrade.

BOTTOMS: *jeans; neutral-colored skirts (any length or shape); slim black pants; menswear-inspired trousers*
As time-consuming as the search may be, you simply must take the time to find the best-fitting jeans, most figure-flattering skirts, and a couple of flawless pairs of pants. The right pieces are invaluable, as they will elevate your style immensely.

ACCESSORIES AND EXTRAS: *black pumps; black shoulder bags; espadrille wedges (black, brown, or tan); flat riding boots; undergarments*
Before you move on to trendy delights, make sure you've got your accessories in order. Every well-dressed woman needs a few effortlessly chic staples to round out her wardrobe.

In short: if it's in a neutral color, well tailored, and a traditional shape— it's probably a timeless essential.

THRIFTY THRILLS
TRENDY AND AFFORDABLE

TOPS: *embellished blouses; sequined boleros; seasonal patterns*
Special finishes—like embroidery, sequins, and zippers—will usually date a top
to a specific time period. Prints are tricky too, so if we suspect the look won't last
longer than a season, we'll find a budget-friendly version with a similar vibe.

BOTTOMS: *print leggings; bright jeans; harem pants; asymmetrical-hem skirts*
When it comes to skirts, shorts, and slacks, if it's a really cutting-edge style, it's
not likely we'll spend lots of cash on it. If a trendy shape really grabs us, we'll
either hit our vintage stores to find a version of the silhouette or pick up a budget-
savvy version at American Apparel or Topshop.

ACCESSORIES AND EXTRAS: *costume jewelry; metallic evening bags; patterned or textured tights; oversized print scarves; fashion belts*
There is little we love more than going on a costume jewelry binge. Stores like
Forever 21 and Urban Outfitters always offer extremely affordable baubles—
like bangles, chandelier earrings, and statement necklaces—that will satiate our
accessory cravings. These shops are also the perfect place to stock up on all the
trendy little extras, including tights, belts, and scarves.

**In short: if you think it might be out of style by your next birthday, stick
with an affordable version!**

UPSCALE SPLURGES
TRENDY AND INDULGENT

OUTERWEAR: *oversized or shrunken blazer; cardigan du jour; little leather jacket*

Sometimes a classic blazer isn't enough, and the season calls for a specific piece of outerwear with a certain fashion-forward cut. So whether it's a shrunken tux jacket or an oversized grandpa cardigan, pick the season's best outerwear option and splurge on it! The same idea holds true for leather jackets: it's never a bad idea to grab this classic piece in a current style—perhaps a zippered motorcycle or a skinny bomber?

ACCESSORIES AND EXTRAS: *high-heeled boots; extreme pumps; trendy handbags*

No matter what happens on the runways, designers always send out some new variation on high-heeled boots and pumps, not to mention the hottest new handbags. You don't need to buy all three, certainly, nor do we recommend getting the most intense styles available. Again, who wants to shell out their savings, only to end up with something super-dated in a month? But if it's something you could imagine wearing numerous times throughout the season or it's a piece that you would pass on to your daughter or granddaughter, we say splurge!

In short: if you want to splurge on a trendy piece, make sure it's a killer pair of shoes, hot handbag, or the season's best outerwear style.

CLASSIC VS. TRENDY
WHAT A DIFFERENCE
A TREND MAKES

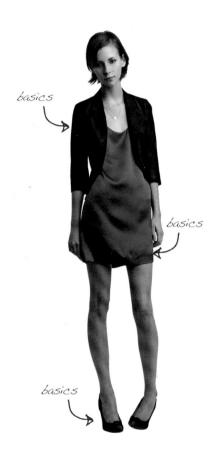

basics

basics

basics

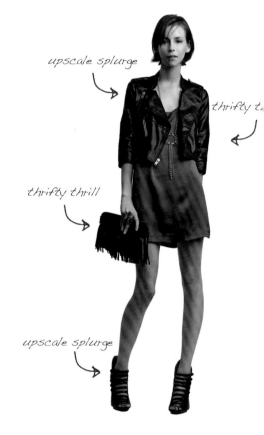

upscale splurge

thrifty t.

thrifty thrill

upscale splurge

CLASSIC

This royal blue shift dress, black blazer, delicate gold necklace, and simple pointy pumps are all classic, well-fitting pieces. Yet there's something missing, isn't there? There is a lack of pizzazz. Alone, each individual item is a smart choice and worth investing in, but together they combine to form a slightly boring outfit.

TRENDY

To freshen things up, we switched the basic blazer for a faux leather motorcycle jacket, traded the dainty necklace for a long, chunky pendant, and exchanged the timeless pumps for some strappy fetish-style heels. The final flourish came via a festive fringed clutch and—voila!—instant style!

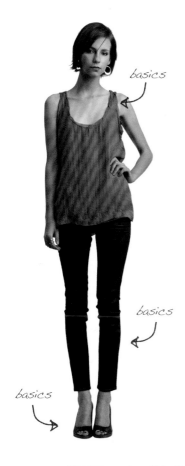

basics

basics

basics

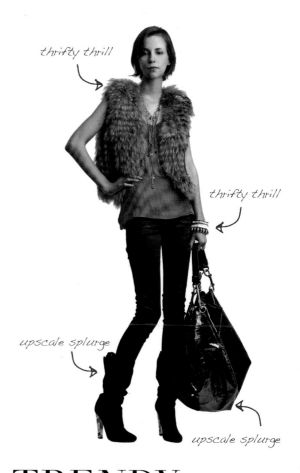

thrifty thrill

thrifty thrill

upscale splurge

upscale splurge

CLASSIC TRENDY

Take stock of our second "before" outfit: one classic silky shell top (check), one basic pair of skinny jeans, (check), and one set of simple peep-toe wedges (check). The pieces combine to form an understated minimalist outfit that's chic, albeit a bit simplistic.

Just by adding a faux fur vest and some Rachel Zoe–inspired statement jewelry, we get a whole new look! Then, to fully seal the deal, we also added an oversized hobo and some slouchy Lucite-heeled boots, stepped back for moment, and were amazed ourselves. Isn't it crazy how a few tweaks can elevate something from timeless yet typical to an outfit that's on-trend and individualistic?

> *When a stylish celebrity puts together a certain look, she can send the whole fashion world into a frenzy. Young girls will want to wear what she's wearing, so the designers will have to respond to that and appeal to the need.*

RACHEL ZOE

chapter

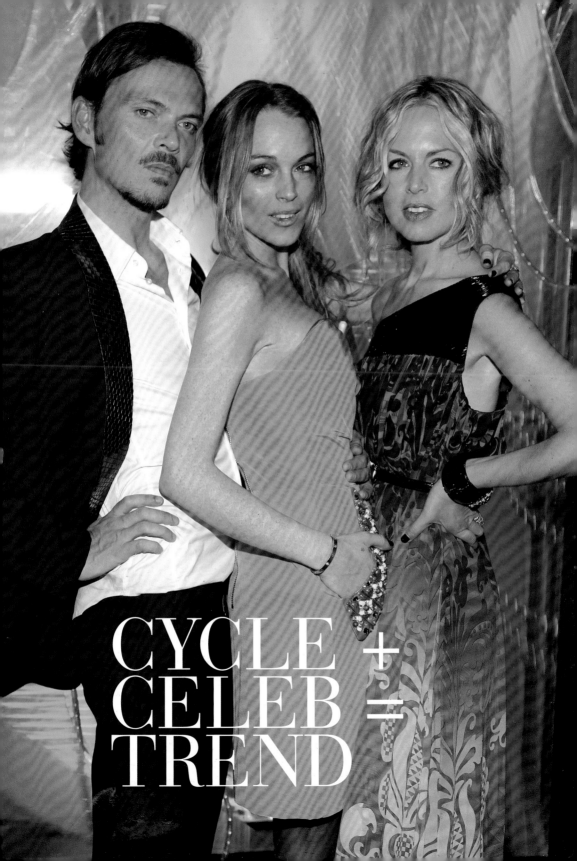

CYCLE
CELEB
TREND

+
=

cycle + celeb = trend

Trends today are moving at hyper speed: remember how long trucker hats were around before they became deeply uncool? They had about five minutes of fame before the backlash and mocking began! Of course, fashion has always been cyclical to a certain degree and, trucker hats aside, major trends tend come back at least every 15 to 20 years. This means that by the time you're in your mid-twenties, it's safe to say you've gone through at least one trend twice, though frankly, it's probably much more than that! Off the top of our heads, we can think of a boat-load of looks that would qualify as "already recycled," like: neon nails, Ray-Ban Wayfarer sunglasses, body-con clothes, punk style (studded belts, skinny pants, leather jackets, spiked jewelry), preppy (loafers, button-ups, capris), grunge (long cardigans, combat boots, flannel, distressed jeans, dark lipstick)—you get the picture.

Of course, this is not exactly unexpected. For centuries, people, or at least the cognoscenti, have been fascinated with of-the-moment looks and changed their outfits accordingly. Even Coco Chanel, a woman wise in the ways of the world, understood the fleeting nature of trends, even saying that "fashion is made to become unfashionable!" Though what Coco couldn't have known is that the style cycle was about to get juiced up thanks to the growth of one little group: paparazzi.

how do trends start?

PARAPAZZI POWER:
ACCESS AND VOLUME

Up until the late nineties, there were only a handful of photographers who took photos of "off-duty" celebrities. But by the turn of the century, their numbers exploded from approximately 25 in the Los Angeles area to an estimated 400 by 2005. The combination of new technology, specifically digital cameras, and falling equipment prices meant that suddenly anyone could be a paparazzo. As their numbers swelled, so did the availability of candid celebrity pictures, which in turn yielded the rise of the celebrity gossip blog and gave magazines like *Us Weekly* an infusion of relevancy.

Now, for the first time ever, the American public (as well as the world's top designers) have immediate access to seeing how some of the most fashionable and innovative women dress themselves on a daily basis. So while style has always been cyclical and impacted by things like the economy, political atmosphere, and designers' whims, suddenly there's an additional major influence the fashion world must contend with: celebrity.

Obviously celebrity has always been important when it comes to setting trends. Whether the style starter in question was Marie Antoinette, Queen Elizabeth, or Zelda Fitzgerald, the masses have long taken their clothing cues from royalty and the ladies of high society. However, in these current climes, people don't have to wait for weeks or months or years to see what the influential crowd is wearing, nor do they have to be a part of that inner elite circle. Anyone can log onto PerezHilton.com or pick up the latest copy of *People* and see what Gwyneth Paltrow is wearing or how Sienna Miller is styling her latest look. The instant access is shifting the typical trend order, as what celebrities wear, and more importantly how they wear it, now has the ability to shape fashion on a day-to-day basis.

CELEBRITY POWER:
EXPOSURE AND AWARENESS

Celebrities have long lived enviable lifestyles—as
you'd expect for the rich, famous, and beautiful
—but their fashion hook-ups are more insane
than ever. They get to wear the latest designer
clothes, sometimes even before the outfits
officially debut on the runway. Fashion houses
will "gift" key celebrities (meaning, people
considered in alignment with the brand) with
the hottest pieces of the season. Or, on a slightly
more practical note, they'll allow certain styleset-
ters to buy these pieces months before they're
produced and available in stores. Obviously the
celebs can afford to buy these items, so why
would a designer give them free stuff?
One reason: publicity.

FROM THE FASHION HOUSE
TO THE FAMOUS

When someone with a rabid following, like Reese Witherspoon, carries
the newest Givenchy Nightingale bag to a Lakers game, she's bound to
get photographed. Those pictures will end up everywhere: fan sites,
Entertainment Tonight, celebrity weeklies, fashion glossies, and yes, on the
pages of WhoWhatWear.com. The bag is cool, certainly, and would have sold
well without Witherspoon, but she can give it the sort of exposure that would
cost millions to buy. Now, instead of just Givenchy fanatics, fashion editors, and
the ultra wealthy knowing about it, the general public knows about the Night-
ingale. Suddenly, girls in Toronto, Taipei, Tunis, Toulouse, and Toledo, Ohio,
are aware of this celebrity-anointed handbag and want to buy it. Not everyone
reads Paris *Vogue* or watches runway footage on Style.com, but most people do
pay attention to celebrities. It's as simple as that.

In addition to impacting their handbag choices, the runways influence the way celebrities dress. For example, Kate Bosworth attended a gala wearing a much buzzed-about dress from Burberry Prorsum's Fall 2008 collection. The gold ostrich feather dress was originally shown with ankle-wrap heels, jet-black opaque tights, a long spiked necklace, a belt, a clutch, and a tallish beanie pulled lower over the model's eyebrows. Bosworth pared the entire look down and only wore the dress with the belt and clutch. Without some of the statement accessories from the fashion show, she was able to make the dress look more approachable and downright wearable.

Sometimes a strong runway look can influence celebrities for years to come. Take Rihanna and her ethnic-print tasseled scarf, for example. The songstress was spotted in New York wearing a fringed Chan Luu scarf around her neck with a white tank, skinny jeans, and gladiator sandals. Rihanna's accessory of choice was clearly influenced by the hugely popular version that designer Nicolas Ghesquiere debuted at Balenciaga nearly two years prior. Clearly, the high-fashion style was so popular and compelling that even trendy tastemakers like Rihanna were affected for seasons to come.

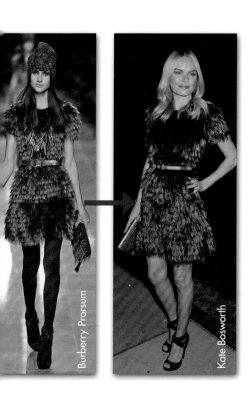

Burberry Prorsum

Kate Bosworth

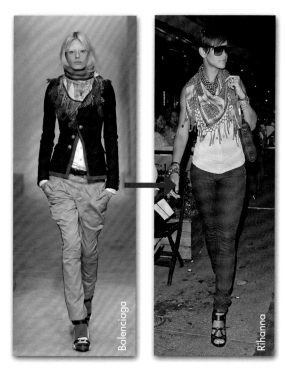

Balenciaga

Rihanna

designer influences

THE CELEBRITY MUSE EFFECT

So fashion designers influence celebrities and celebrities influence us, as well as their fellow famous peers—but that's it, right? Wrong! These days, style is not a one-way street, but rather a fashion thoroughfare with ideas and influences whizzing by each other at high speeds. That means that some of the world's most renowned and important fashion houses and designers look to their favorite famous females as muses and create collections that directly reflect the stars' personal style.

INSPIRATION AT DIOR:
THE SISTERS OLSEN

We first noticed the symbiotic inspiration relationship between designers and celebrities back in the fall of 2004, when studying the first dozen or so looks shown at the Christian Dior Spring '05 show. When we saw that Dior's designer, John Galliano, sent out models sporting lanky, slightly disheveled, wavy hair and wearing slouchy knit beanies, floppy wool hats, big bug-eye sunglasses, and chunky jewelry, we freaked. It was so MK and Ashley we could barely speak! During the following season, the fashion house offered more of the same, and the models stomped down the Dior Fall 2005 runway in oversized pieces, lots of layers, and more extra large-accessories. In short, the looks were a full-on ode to the Olsens. Though this time around, we had proof we weren't the only ones with the sisters on the brain, as Galliano cheerfully admitted to the press that the fall collection was completely inspired by Mary-Kate and Ashley Olsen.

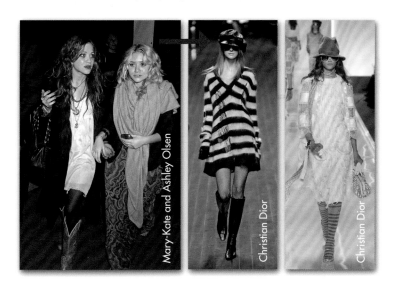

Mary-Kate and Ashley Olsen · Christian Dior · Christian Dior

Is it odd that two eighteen-year-old (at the time) actresses could influence the course of a fashion house? Yes, perhaps, a little! But that is the power of celebrity: certain famous people have the ability to fascinate everyone, from top tastemakers to average Janes everywhere.

INSPIRATION AT CHANEL: BAD GIRLS

Of course, Galliano isn't the only couturier who draws inspiration directly from pop culture princesses. The one and only Karl Lagerfeld—currently the designer for Chanel, Fendi, and his eponymous line, Karl Lagerfeld—revealed his influences in Chanel's Spring 2008 collection. The show, which took place in October 2007, was only a few months after both Eve and Lindsay Lohan were arrested for drunk driving. TMZ devotees will remember that the two stars were forced to wear electronic ankle monitors, which they did, sometimes while wearing shorts or bikinis. The paparazzi had captured their every move, pictures that the designer clearly saw. How do we know? When the models came out for that Spring 08 show, many were wearing tiny quilted ankle bags, an accessory that owed its conception to these celebrity antics.

Eve

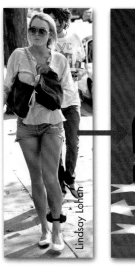
Lindsay Lohan

Chanel

Chanel

Kaiser Karl didn't stop there! The very next season (Pre-Fall 2008), the Chanel models stepped out onto the runway with thick, black, winged eyeliner and giant puffy beehives (complete with horsetail-like extensions cascading down their backs). It seemed that Lagerfeld had chosen another unlikely, tumultuous muse—British bad girl songbird Amy Winehouse. The much-celebrated, much-troubled neo-soul singer is known for her heavy-handed eyeliner plus a disheveled pseudo up-do, a signature style that Lagerfeld clearly aped for that collection.

celebrity influences

THE TRICKLE DOWN EFFECT

In addition to drawing attention to or influencing a particular designer or piece, some celebrities can also ignite certain trends that would otherwise languish in obscurity. Would fedoras have ever come back into mainstream women's fashion if Kate Moss hadn't worn them in early 2005? Perhaps not. Aside from these individual influencers, groups of celebs can also be responsible for how long a trend lasts. Take, for example, the lace-up Minnetonka moccasin.

THE MINNETONKA MINUET

If trends threw a giant gala, one fad that would have a full dance card is the Minnetonka moccasin. Frankly, at first glance, the shoe seems like a bit of a wallflower: it's simple, specific, but not overly stylish. Yet, despite its nonshowy looks and lack of promotion, this lace-up boot has been a relevant and powerful trend for more than four years!

Are you curious as to who instigated this footwear fad? Well, surprise, surprise, the celebrity who sparked the trend is none other than Kate Moss. One day in 2004, Ms. Moss decided to pull on a pair of these Native American–inspired boots. She paired them with a vintage tee, some leggings, and her favorite Alexander McQueen scarf, and suddenly a shoe trend was born!

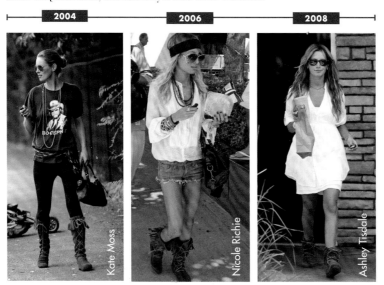

In 2006, we noticed that the Minnetonka had made its way to Hollywood. It seemed that the trend had officially trickled down to a new set of famous feet—specifically, Nicole Richie's—and was influencing people anew. Richie wore her lace-up moccasins with a flowing white shirt, some wooden beads, and a hippe headband, which just so happened to be in perfect keeping with the boho-mania of the time.

But that was not to be the last time the Minnetonka two-stepped into the spotlight, oh no! *High School Musical* star Ashley Tisdale picked up these same shoes, albeit in a slightly shorter style, circa 2008. The accessory du jour changed—the Alexander McQueen scarf became boho beads; boho beads were replaced with Ray-Ban Wayfarers—but the look is still the same. We can't help but think Ms. Tis was inspired by the stylish ladies before her. You see, by the time the Minnetonka meringued into our young Disney star's mind, every major shoe brand was making a version of the fringed footwear, and soon every mall-rat in town would have a pair!

THE HIGH-WAIST WALTZ

The Moss Effect is not limited to the recent popularity of suede moccasin boots—oh no, no, no. She's even got the golden touch when it comes to that most fickle, trend resistant of items: jeans. Starting in the late nineties, the denim look that ruled the world was the low-rise jean, usually in a dark wash and, especially in the mid-2000s, a super-slim fit. These nearly-leggings were de rigueur and were accepted by all as a cool choice—the only choice. But then, one night in February 2006, Glossy Mossy did the unthinkable: she strolled out wearing a pair of ultra-high-waisted skinny jeans from the British brand Ghost's Fall 2006 collection. Her revolutionary choice was still slim in leg, but it sported a waistband that came up nearly to the bra-line—very extreme. In that one outfit, she sounded the death knell for muffin tops everywhere. (The final nail in the low-rise coffin came when she wore a pair of high-waisted, wide-leg vintage Chloe jeans to London's Fashion Week in September 2006.)

Admittedly, Moss is not the first woman in the world to wear high-waisted pants—clearly she is not-so-secretly channeling muses like Jane Birkin and Katharine Hepburn—but she was definitely the celebrity front runner for this look. The following year, Mischa Barton took a turn dancing with the retro silhouette. The TV star was snapped in April 2007 wearing a high-rise pair of 18th Amendment Bacall jeans with a tucked-in vintage tee and a pair of studded black ballet flats.

At that point, everyone got the memo: hide your whales' tails and pull on some rib-grazing jeans. Next thing you knew, even Hilary Duff was spotted in a toned-down pair. Seen here leaving the Beverly Hills outpost of Barneys New York in May 2008, Duff modeled the least fashion-forward version of the look. Her jeans have a more moderate high waist, wider leg, and less detailing than the edgy pair that Kate Moss wore, or even Mischa's selection. Duff's outfit choice transformed something that was "risky"—or at least risky for early 2006—into an approachable outfit. It's a classic example of a trend's tipping point: when a mainstream celeb starts wearing something that was considered cutting edge, that look has officially gone mass.

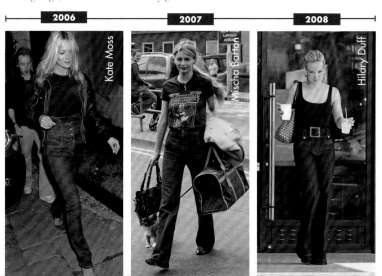

2006 — Kate Moss | 2007 — Mischa Barton | 2008 — Hilary Duff

> *If you see a trend on a popular TV show,*
> *you know it's officially mainstream.*
> NICOLE RICHIE

chapter

6

THE
TIME-OUT
CORNER

the time-out corner

When we were little, our exuberant behavior periodically got us sent to our progressive schools' "calm corner," where we reflected upon our social sins and took a breather from circulating on the playground. A mere fifteen minutes later (which is eons in grade school time), we returned to our activities knowing a little bit more than we did before. Chief amongst these lessons learned was the idea that ubiquity inevitably results in unpopularity. In plainer terms: if you're everywhere, all the time, everyone gets sick of you.

Amusingly enough, this moment of schoolyard clarity is actually quite relevant today, especially when applied to fashion fads. At Who What Wear headquarters, we're always getting alarmed calls and emails from ladies who are concerned about the present state of any given trend. These readers know that momentary styles—like deep plum nail polish or pirate-inspired accessories—can flip from the divine to the dreadful in the blink of an eye. However, they don't know how to monitor the trend themselves or what to do when the look is officially finished —hence all the questions!

We can happily tell you that managing and retiring trends isn't a labor-intensive process. In fact, it merely requires the same solution that a coke-fueled starlet or booze-crazed designer needs. When a look becomes tired, just send the over-the-moment items to the fashion-version of rehab: the Time-Out Corner.

the big "don't"

Aside from a few general, well-known, and obvious rules (such as: don't wear a denim jacket with jeans), it's pointless to make universal style proclamations, as these alleged fashion faux pas are actually quite subjective. Come to think of it, for just about every style "don't" we can think of, we can immediately come up with an example of a trendsetter wearing that look in way that makes it a "do."

Case in point: Kate Hudson often wears slightly sheer or diaphanous tops, but she styles this tricky item flawlessly by wearing it under a sharp blazer. The tailored jacket adds a little modesty and makes the see-through shirt appropriate. So while no one would recommend that you wear a transparent top and hot pants to your office holiday party, Hudson shows that there is a way to work this piece into a sophisticated outfit.

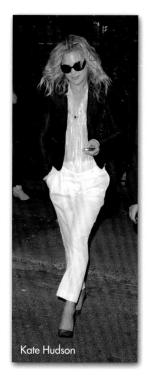

Kate Hudson

However, all of this positivity aside, there is one particularly loathsome fashion malady that needs to be discussed. The condition, most commonly known as "trend oversaturation," is an affliction that is as abhorrent as it is prevalent, which is why understanding its pathology is of paramount importance. Fortunately, containing and controlling this unstylish affliction is possible. With a little work, you will be able to recognize and diagnose any tainted trend and make sure your closet doesn't get infected!

trend oversaturation

Whether you're aware of it or not, you've probably witnessed a trend or two hitting its saturation point in front of your very own eyes. Have you ever woken up one morning, gone outside, and suddenly realized that everyone, including you, is wearing the same thing? You feel gross, unoriginal, and suddenly are desperate to get the offending piece off your body and into the trash. That feeling of icky awareness, dear readers, is exactly what we're talking about!

After a trend peaks and has definitively spread to the masses, the look is then officially exhausted. Now, keep in mind that we're not using the word "exhausted" in the celebrity sense (as a euphemism for partying too much), but rather in the literal sense, meaning suffering from extreme fatigue. Not all trends are affected by this condition—some just gently fade away—but the biggest and most rapidly spreading ones invariably do. Unsurprisingly enough, celebrities are the direct cause of the recent fashion fad epidemics.

As we referenced in the previous chapter, Cycle + Celeb = Trend, an of-the-moment look will trickle down through the celebrity hierarchies, cycling through the most stylish girls first. These famous females influence each other, as well as the general public, and play a role in how long that look will loiter around.

That said, the most overwhelming, ubiquitous, and annoying trends go through two stages before reaching the point of oversaturation. First of all, celebs wear the trend and create the initial buzz. Secondly, mass brands quickly get their knockoff version of the look into malls and/or drugstores, giving consumers easy access to an affordable version of the trend. When a trend passes through these two stages it then spreads super quickly, hitting multiple demographics— from city hipsters to country kids—simultaneously, at which point it's so popular it officially becomes revolting.

RECOGNIZING THE SYMPTOMS

People are always concerned about whether or not a trend or style is still cool, but frankly, we think the answers are usually pretty clear. (In short, if you have to ask, it's probably not.) However, if you're really unsure, we suggest that you just ask a few simple questions.

1. *Who is currently wearing the trend?*

a. Tastemakers: fashionable celebrities, socialites, and models

b. Impersonators: random ladies in the grocery store, your manicurist, middle schoolers

2. *What is it worn with?*

a. Classic and timeless items

b. Ultra-trendy gear

3. *Where has it spread?*

a. Only cutting-edge boutiques and high-end department stores

b. Knockoff versions are available at mass discount chains

If you've selected the letter B for any of the above questions, your trend may be suffering from oversaturation.

TIRED TRENDS:
CASE STUDIES & EXAMPLES

1. *Acute communiskirtus*

Perhaps you fell in love with Mary-Kate Olsen's post–Cirque Lodge summer wardrobe, or maybe you just wanted a smidge of Sienna Miller's seemingly carefree spirit, circa *Alfie*. Whatever the reason, in the mid-'00s, a boho basic swept the world, and suddenly everywhere we looked, people were wearing peasant skirts.

Much like the poncho pandemic that followed, for a moment, the whole world went earthy as everyone from tweens to pseudo-seniors snapped up these long-tiered skirts. Though this item really looks best only on tall, hipless women, the skirt seemed figure-friendly enough for every designer (from Fendi to Forever 21) to whip up a version. Worn with embroidered sandals, hip-slung belts, and vintage T-shirts, the peasant skirt was officially diagnosed as "out" until further review.

2. *Hyperhatsimilis syndrome*

Hollywood loves a hat trend, so we weren't surprised when the fedora started making the rounds again in 2004. Once the providence of gentlemen and giant legends like Frank Sinatra, the fedora became the topper of choice for paparazzi-shy stars, like Keira Knightley, and lens-loving ladies, like Lindsay Lohan, alike. Then, during the summer of 2008, the straw fedora exploded on the scene and you couldn't open a celebrity weekly without getting an eyeful of the chapeau style. While the fedora will remain a classic in many ways, we benched ours for a few seasons.

3. *Chronic gladiatoris sandalium*

Blame it on Russell Crowe, Jackie O, or any number of Nicolas Ghesquiere's collections for Balenciaga between 2004 and 2008, but for the past few years, we've noticed that many young women have been suffering from a chronic case of gladiatoris sandalium. Instead of the relatively simple, flat, strappy styles that were traditionally popular, in Spring 2008 the shoes got an extreme makeover.

Fashion houses like the aforementioned Balenciaga and Givenchy showed over-the-top versions with ultra-high heels and winding straps that climbed up the leg. Adopted by celebrity trendsetters galore, the statement-making trendy version were so in-your-face that the look immediately became oversaturated and was sent on hiatus.

4. Digiti ubique

Beauty trends are also afflicted by overzealous fads, and nail polish trends seem particularly susceptible to getting played out. Remember the neon wave that swept through manicure salons like wildfire in Spring and Summer 2008? Well, prior to this, there was a particularly viral outbreak of basically black nail polish, circa Fall 2006. We'd been wearing deep purple or burgundy lacquer for a year at that point, because it reminded us of another beloved dark color: Chanel's Le Vernis Nail Color in Vamp. When it launched in 1994, the blood-black polish created quite the stir, and after ten years, we decided it looked fresh again.

Unfortunately our gothic polish caught on, and suddenly we noticed that everyone in the salon was fighting over the same bottle of OPI's Lincoln Park After Dark. Sadly, there's no statement to be made when Beverly Hills moms and their daughters are cultivating your "edgy" look. So we had to relegate the polish to the back of the beauty cabinet until it feels fresh again.

THE CURE

In conclusion, though it's painful at first, and sometimes difficult to imagine how you'll possibly live without your go-to clothing item or beloved beauty product, some trends simply must get sent to the Time-Out Corner. Don't worry, you're not banishing it forever! In fact, after a season or two of being out of the public eye, you just might be able to bring that trend back and enjoy it anew. But until then, to the Time-Out Corner it must go!

Seasonal makeup trends present a modern vision of beauty that inspires and shapes how we see ourselves. You don't have to wear every new style that comes down the runways, but keeping current with what's "now" tells the world that you're modern and open to new possibilities. Plus, an awareness of the latest trends gives you the freedom to adapt them to your personal style for a tailor-made approach to beauty.

PAT MCGRATH

chapter

7

IN THE
BEAUTY
CLOSET

in the beauty closet

Like most girls, we were wild about beauty products long before we were technically allowed to wear them. Growing up, the second our parents would leave the house, we'd immediately dart to our mom's bathroom and binge on her electric-blue eyeliner, ultra-violet mascara, and bright coral crème blush.

After carefully painting our faces, we'd plug in her hot rollers or fire up the crimper and get to work on transforming our hair from its natural state of long, lank locks to tremendous sculptural works of art. As we admired ourselves in the mirror for a minute or two—we only had moments left before we had to hop in the shower and scrub off all our hard work—we marveled at how, with a little product and preening, we could go from looking like the kid next door to Madonna's much younger sister.

At some point in high school, our technique finally improved, and we realized the true transformative power of having an on-trend beauty look. We might not be able to buy all the designer clothes we wanted, but we always knew we had one secret weapon that would help us seem au courant for minimal cash: the drugstore.

BEAUTY BASICS:
WHY IT MATTERS

Remember how we recommended picking up a trendy jacket or coat each season in *Investing in Trends?* Well, the reasoning behind that recommendation holds true for beauty too. If you update your hair and makeup each season, you'll give the impression that your entire head-to-toe look is in style. Even if you're wearing really classic clothes, these little grooming updates—wearing that season's key lipstick shade, polishing your nails in a hot color—will keep you fashionable.

On the flip side, if you don't pay attention or make these little alterations, you can date yourself in a split second. If the cognoscenti have all moved on to nude nails and you're rocking something bold or statement making, you'll just look ultra-passé.

Additionally, beauty trends have brevity on their side: unlike fashion fads, there are a limited number of beauty looks that phase in and out of style. In any given season, you might have to decide which of the thirty different clothing and accessory trends work for you, but there are usually less than five key hair and makeup styles to consider in that same time period. This means that deciding what looks you like is a pretty quick and easy process—always a good thing in our pressed-for-time lives!

DEPARTMENT STORE VS. DRUGSTORE:

BEAUTY BENEFITS

Of course, like most people, we love designer or prestige beauty products. We always fall in love with the new nail polish colors Chanel puts out every few months, adore all the beautiful shades of Stila eye shadow, and swear by our MAC and Laura Mercier brushes. But aside from a few key products, when you shell out for those department store designer cosmetics, the majority of what you're paying for is pretty packaging and the luxury of trying on the products before purchasing them. (Or, in the case of hair products, pretty packaging and fancy scents.)

On the other hand, mass-market brands, like CoverGirl and L'Oreal, might not give you the same glossy compacts or come in a gorgeous box, but the actual eye shadow or shampoo will probably work just as well, for a fraction of the price. The reason for this is simple: huge cosmetics corporations own most beauty lines. For example: Procter & Gamble owns Frederic Fekkai, a luxurious brand started by the celeb hairstylist, as well as supermarket staples like Herbal Essences, Pantene, and Aussie Hair Care. L'Oreal Inc. oversees drugstore favorites like L'Oreal Paris and Maybelline New York, but they also own makeup artist favorite brands like Lancome, shu uemura, and Giorgio Armani Beauty.

Why are we telling you all of this? Because those major mass brands benefit from any technological advances, fantastic formula discoveries, and inspired new product creations. We're not saying that Lancome's best-selling Juicy Tubes Jelly Ultra Shiny Lip Gloss (which costs about $18 a tube) is exactly the same as L'Oreal's Colour Juice Sheer Juicy Lip Gloss (around $8 a tube), but the formulas and shades are pretty similar.

CREATIVE ADVISORS

Another reason that we swear by drugstore beauty brands is because most major companies now have extremely talented makeup artists as their creative consultants. In 2004, Procter & Gamble Beauty made an exceptionally smart move when they hired Pat McGrath to be their creative design director. McGrath might be the single most influential makeup artist in the world and is usually responsible for at least 50 percent of the key makeup looks that walk down the runway in any given season. If she decides she likes raspberry sorbet blush worn on the temples, dramatic glossy black eyelids, or jewel-encrusted ruby lips, sooner or later, you'll be wearing those looks—or at least some variation!

Now that McGrath works with P&G, she not only uses the company's mass brands (CoverGirl and Max Factor) in her backstage makeup kits, which gives them a sprinkling of glamorous fairy dust, she also helps create products directly influenced by her runway work. For example, McGrath helped develop CoverGirl's True Exact liquid eyeliner pen, which she used to create the "winged eye" look (it's basically a cat-eye gone wild). Still seen on the runways, celebs, and fashionable girls on the street, that eyeliner style is going strong, and the product is flying off the shelves.

Of course P&G isn't the only company that looks to experts to get insider information and a certain glamourous cache. Well-known celebrity makeup artist and backstage regular Gucci Westman became the Global Artistic Director for Revlon in 2008. The visionary James Kaliardos, who's worked on runway shows ranging from Rodarte to Hermès, is a creative consultant for L'Oreal Paris. Even Charlotte Tilbury, one of the world's top high-fashion makeup artists, created Myface, a line of ultra-affordable makeup for Boots, the UK's main drugstore chain. On the hair side, runway king Guido Palau is a creative consultant for Redken, while hair heavyweight Danilo (the go-to guy for Gwen Stefani and John Galliano's runway shows) is a spokesperson for Pantene.

By bringing these high-profile hair and makeup artists on board, the mass brands became just as socially acceptable and "cool" as department store brands. These artists can dish about what's going on backstage—specifically, the upcoming season's crucial makeup and hair looks—and give the company their of-the-moment counsel (say, that they should develop a heat-protecting hair balm or turquoise eye shadow). By having access to these ultra-talented people, the beauty brands shape their roster of products to fit the upcoming trends and create new products based on their insiders' input.

SKIMP OR SPLURGE?

You can always find high-quality products at the drugstore, but, depending on the item, there is something to be said for the pricier department store brands. When it comes to certain pivotal products like foundation, you should ensure that you look your best by investing in the best. That said, it's time to break down your beauty buys and play one of our favorite games: Skimp or Splurge!

HAIR PRODUCTS

Skimp On . . .

SHAMPOO: Brands like Herbal Essences, Garnier Fructis, L'Oreal Vive Pro, and Aussie Hair Care will clean your hair just as well (and gently) as a salon version.

HAIR DRYERS: Just look for a lightweight style that comes with a nozzle tip (for more accurate drying). When it comes to styling, heat is the ticket, so make sure you pick a model that has at least 1,600 watts. Don't worry about whether it's ceramic, ionized, or has multiple heat and cool settings—these are all unessential bells and whistles.

SERUM: Smoothing agents are all the same, so pick a budget-friendly product that has either cyclomethicone or dimethiconol listed as the first ingredient. The drugstore classic, John Frieda's Frizz-Ease Hair Serum, usually runs about $20 less than the salon version.

Splurge On . . .

CONDITIONER: Drugstore shampoos are a great place to skimp, but we think it's worth splurging on a conditioner. Whether it's nourishing dry hair or protecting damaged or color-treaded locks, a great conditioner can really give you some lasting benefits.

HAIRSPRAY: Products like L'Oreal Elnett and Kerastase Hair Spray are formulated for professional use, so they will hold your hair but still are easily brushed out. Most mass brands only freeze a style in place and are stiff.

HOT TOOLS: Go ahead and save up for a pricey curling or flat iron, as they will heat up more evenly and to higher temperatures (necessary for quickly achieving a style) than their drugstore cousins.

MAKEUP PRODUCTS

Skimp On . . .

TRENDY COLORS: If you're interested in a bright, bold, or super trendy color, try to find it at the drugstore first. There's no point in shelling out $30 for an of-the-moment hue that you'll wear three or four times.

LIP GLOSS: Almost every mass-market brand makes an excellent gloss formula in a range of colors. We like Revlon's Super Lustrous Lipgloss, Max Factor's MAXalicious Lipgloss, and L'Oreal Color Juice Sheer Juicy Lip Gloss.

WATERPROOF MASCARA: Whether you use it for your lower lashes year-round or just like it for summer beach days don't invest in waterproof mascaras.

Splurge On . . .

SKIN MAKEUP: When it comes to foundation, tinted moisturizer, concealer, and powder, it's worth it to invest in prestige face products. Finding an exact match is crucial and usually requires trying on a few different colors and formulas.

BRUSHES: Much like kitchen knives, you don't need a thousand different types of brushes. Just invest in a few high-quality ones and you're set!

EYE SHADOW: Though we advocate skimping on trendy eye shadow colors, definitely invest in hard-working neutrals. Stila, MAC, and Giorgio Armani shadows are finely milled and deeply pigmented, meaning easy application and beautiful buildable colors.

DEALER'S CHOICE . . .

There are a few product categories that we haven't mentioned that you might be curious about. Well, dear readers, that's because it's dealer's choice!

EYELINER: Most makeup artists' favorite liners are by prestige brands (MAC's Eye Liner in Teddy and Chanel's Le Crayon Khol in Ambre specifically), but we've found some killer inexpensive versions, like Jillian Dempsey for AVON's Professional Kohl Eye Liner, Max Factor's MAXeye Liner, and Maybelline's Line Stylist.

BLUSH: Feel free to go to the drugstore or the department store for blush, just make sure you pick a pretty, natural color in a formula of your choosing. One good way to select the right shade is to pinch your cheeks and then look for a similarly rosy hue.

MASCARA: If you go for a relatively natural beauty look, inexpensive mascara will definitely do the trick. Maybelline and L'Oreal offer formulas and brush styles that are remarkably similar to the options available from pricey luxury brands. That said, if you like a more dramatic lash for your everyday look, it might be worth upgrading to Dior DiorShow Iconic Mascara, Chanel Inimitable Mascara, or Lancome Definicils High Definition Mascara.

chapter

WHAT TO WEAR WHERE

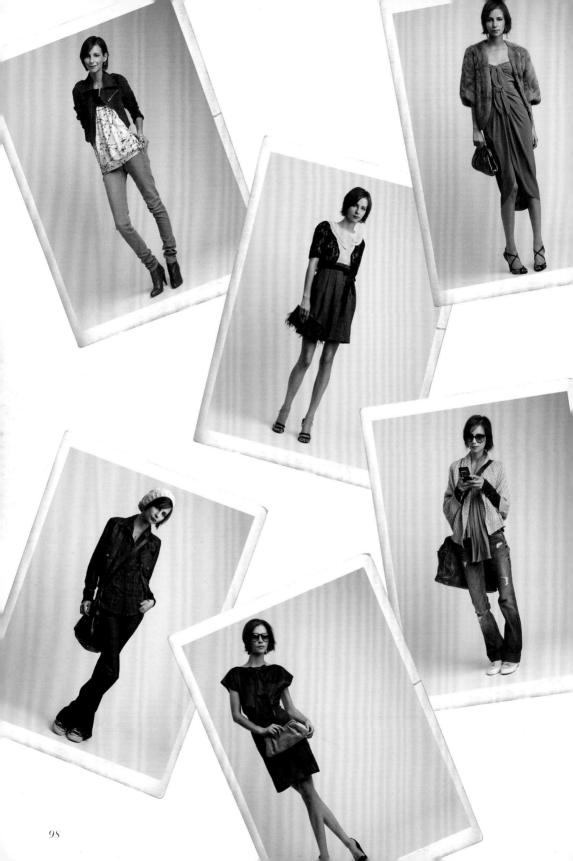

what to wear where

We assume that you, dear reader, are like us, and that you have a calendar that's packed with a veritable cornucopia of date nights, parties, and other such social situations. Or even if you don't have such a frantic schedule, surely you go out from time to time, and when you do, indubitably, there's a range of events you must attend.

Either way, we're guessing that you've had a moment or two, when you accepted an invitation and then immediately though: "Drat! I have no idea what I'm supposed to wear." In the hopes of soothing said concerns, we created a very detailed list explaining What to Wear Where—or wardrobe resource guide by occassion. Read on for our thoughts about the ideal outfits for a variety of occasions, the key pieces you need to create said look, and what to avoid in your ensemble.

WWW WORDS OF WISDOM
Just because bra straps come in clear, it doesn't mean it's okay to show them. If you straps are going to show, make them obvious by going for a fun color or stick to black. Nude or clear bra straps are never sexy.

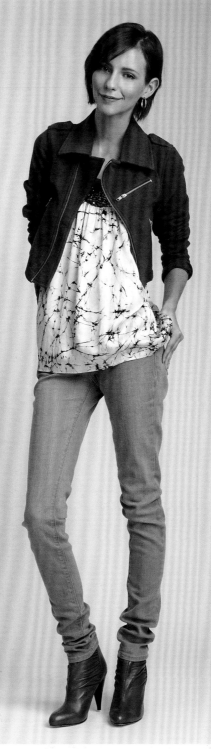

art gallery / art opening

art gallery/art opening

When you're putting together an art gallery outfit, keep in mind that your attire should be similar to what you'd wear on a dinner date at a cool restaurant. The base of your look should be relatively classic, but liven things up with at least one fashion-forward piece: a cool printed scarf, of-the-moment shoes, or even a fantastic piece of outerwear, like a cropped coat in a bright hue or a little leather motorcycle jacket. The goal is to create an outfit that's a bit dressier and edgier than what you'd wear to work, but not as saucy as something you'd choose for a girls' night out.

It's important to look and feel comfortable, so it's absolutely fine to wear denim, but please pick jeans that are either gray or in a dark wash, as they're a bit more polished than regular blue ones. Black pants are also a great option, especially if they're in a skinny/slim cut for a bit of sex appeal. Either way, just be sure to balance these slightly basic bottoms with something that makes a statement, like a trendy top or killer heels.

If you're more of a dress girl, just make sure you choose a style that doesn't show too much skin. If your frock of choice is low-cut, balance it by adding some opaque tights, and stay away from ultra-tall shoes because bare legs and super-high stilettos are a little sexy for an art opening. If your dress is short, make sure you're covered elsewhere: a snug blazer will add modesty and interest to your outfit.

Finally, don't forget that the lights in an art gallery are usually very bright, so you will end up feeling uncomfortable if your outfit is over the top or revealing. Keep the atmosphere in mind when determining your beauty look too.

go for
Gray or black jeans or slim black pants; solid-colored dresses; tights; ankle boots or interesting pumps; shrunken blazers, motorcycle jackets or cardigan-jacket hybrids; trendy tops; patterned scarves; natural lip gloss

steer clear of
Cocktail dresses; corporate clothes; super-casual duds; high platform heels; heavy blush or makeup

risky business
Denim; short hemlines; low-cut necklines

what we'd wear
A trendy, art-inspired silk top, gray skinny jeans, vibrant-blue cropped jacket with zipper details, and some awesome dark gray ankle boots

benefit / fundraiser

You've got a least one friend who's always trying to get you to donate to their latest cause and just asked if you'd purchase an overpriced ticket to their fundraiser du jour. Since you're a good friend (and citizen), you accept the invitation, but now you're stumped about what to wear to the event. The goal is to create an outfit that's classic and a bit demure. It should also be able to cross over into a religious occasion, like a bar/bat mitzvah or christening. Notice that we didn't include "boring" in that list? Our point: make sure your outfit always includes something unexpected—like a feathered clutch or piece of statement jewelry.

We suggest that you invest in one fantastic frock that you can wear over and over throughout the philanthropic season. If you pick the right style, you'll be able to take it from day to night or a casual situation to cocktail hour! As a general rule, it's best to avoid any dress that's low-cut or short: hemlines that hit just above or below the knee are ideal. It's also a good idea to find a light-weight outerwear option, such as a shrug or wrap, to cover your shoulders and create a more modest outfit. Also, since this is a relatively conservative occasion, you should choose a dress in a neutral color—gray, brown, camel, or even blush.

A feminine pantsuit can also be chic, provided that you accessorize it correctly! If you're attending a fundraiser at night, try a pretty silk shell under your suit and add either some dressy, cocktail-appropriate shoes or an embellished clutch. If it's a daytime affair, go for a girly blouse, nude pumps, and a colorful bag.

go for
Gray or navy knee-length dresses; capelettes or three-quarter-sleeve jackets; embellished clutches; modest heels

steer clear of
Bare shoulders and plunging necklines; floor-length dresses (unless it's black tie); sequins or metallics; platform heels; edgy accessories (zippers, chains)

risky business
Suits; bright colors

what we'd wear
A two-toned ivory and gray dress with a separate lace shrug, feathered clutch, cocktail ring, and open-toed medium-heeled pumps

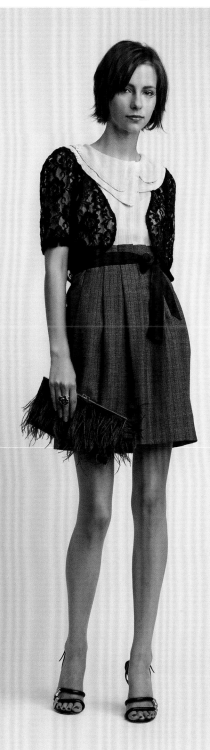

benefit / fundraiser

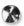

black tie wedding

black tie wedding

In this day and age, when it comes to women's dresses, cocktail and black-tie are, for the most part, considered one and the same. Naturally this leads to lots of confusion. We've gone to countless weddings where half the party looks like they're going to the Oscars while the other half appears to have wandered in off the street. The goal is to create an outfit that's formal and chic but still has a few fun details. Overall, we think it's better to err on the slightly overdressed side, rather than looking too casual. (It's a politeness issue: if you're very underdressed it tells your hostess you couldn't be bothered to make an effort. Rude!)

If the wedding is taking place in a big city like New York, Chicago, San Francisco, or Dallas, you may feel more comfortable in a long dress, simply because people tend to dress up a little more in these areas. Smaller cities and towns tend to be slightly more casual, so a fancy cocktail dress will definitely be appropriate for most black tie weddings.

Wherever you are, remember to avoid casual fabrics—including cottons, jerseys, and polyester—at all costs and pay close attention to your accessories. A fabulous evening bag and sparkly shoes can dress up a basic, low-key dress, and a unique cocktail ring can be an interesting conversation starter. Color-wise, while it's still inappropriate to compete with the bride and wear white or cream, you can forget the old-school rules about not wearing black or bright colors. If you do want to wear an attention-grabbing shade like hot pink or bright yellow, please be cautious and remember to balance the intensity with neutral accessories, like a gray wrap or nude shoes. If you're simply dying to wear red, it's best to stick with a short style, as a long red dress is too attraction grabbing.

go for
Jewel tone, black, or navy dresses; floor-length or cocktail-length dresses; interesting, embellished accessories; faux-fur jackets or shrugs

steer clear of
White, cream, or ivory dresses; revealing cuts (too low, too short, too backless); casual fabrics (cotton, jersey, or polyester)

risky business
Sequins; prints; bright colors; red dresses

what we'd wear
A strapless, vintage, emerald-green dress that hits the middle of our shins, gray fur wrap, gold and black strappy high heels, and a metallic evening bag

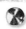

casual date

casual date

You'd think it would be easy to figure out what to wear on a casual date—usually your second—but it's invariably nerve-wracking! These less formal outings, like a trip to the museum in the middle of the day or going to the movies on a Sunday evening, are frustrating because it can be difficult to create a look that says the right thing. The goal is to create an outfit that's low-key and playful, something that's come hither, but not hootchie!

We'll start our casual date outfit suggestions by recommending America's favorite fashion security blanket—jeans! There are obviously many different options when it comes to denim, so just pick the cut and color that flatter your body the most. We prefer a wide-leg jean for this situation, simply because this cut allows us to wear our favorite casual date shoe—wedges! Unlike pumps, wedges are more comfortable to walk in and give you a more relaxed stance than your typical heel. Another excellent cold-weather shoe alternative is a flat knee-high boot over a skinny jean. The height of the boot is casually sexy while the low heel height tones everything down. Plus, if there's one thing we've noticed, most men love their ladies in boots.

As for the rest of your outfit, look for a shirt that shows your curves, especially your waist, but isn't too cleavage focused. If you are typically more comfortable in a looser top, you can avoid the maternity look by belting your billowy top at the waist. Another easy fix is to add a shrunken, tailored, menswear-style vest, as this will slim down the shape of a voluminous shirt.

If the date is taking place during warm weather, we love a light sundress with a denim jacket or a fitted cardigan. If your dress is shapeless, the same waist-management rule applies: add a belt under or over your cardigan.

Regardless of your final outfit decision, embellish your look with thoughtfully chosen accessories! Bohemian girls, break out your little beaded necklaces, prepsters, pull out your headbands, and rocker gals, strap on your studded cuffs. Last, but not least, whatever you do, please avoid wearing heavy makeup on your casual date. It just looks a little gross and desperate. Period. Also, skip any shoes you would normally wear out with your friends on a Friday night. Club heels are not going to convey the appropriate message on movie night!

go for
Figure-flattering jeans; feminine tops; wedges or flat boots; sundresses; denim jackets; chain necklaces or delicate stacked bracelets; soft makeup and hair

steer clear of
Hats; shapeless tops; baggy pants; high-heeled pumps; red lips and smoky eyes

risky business
Blazers; loose or low-cut tops or dresses

what we'd wear
Wide-leg jeans, a loose lacy top nipped in at the waist with a wide brown leather belt, gold chain necklaces, bangles, and wedge sandals.

concert

There are a few things to take into consideration when dressing for a concert: you'll probably be on your feet all night; outdoor shows mean you might get freezing cold; and you should look as cool and sexy as possible, just in case you get called on stage to sing to your favorite song. (Okay, maybe the third one is a bit of a long shot, but there's nothing wrong with dressing for a best-case scenario!) The goal is to create an outfit that's unfussy, a little bit edgy, and includes a few easy-to-layer pieces.

That said, we always start our concert outfits by first picking a great pair of pants. Whether we end up wearing jeans—ideally black ones; they're best for night—or faux leather/liquid leggings, the rest of the outfit's a snap. Just add some comfortable, low or mid-heeled ankle boots, a leather or denim jacket (just mix it up, no leather-on-leather outfits or denim suits, please!), and a worn-in vintage T-shirt to dress the whole look down a little.

It's nice to have a big bag, since this means you can bring along a blanket, extra layers, or even some snacks. A cross-body bag is the ideal solution because it ensures that your purse will be on your person at all times, and it keeps your hands free.

As far as absolute no-nos, stay away from short skirts—they will limit your activities. Generally speaking, we suggest that you avoid long skirts too, as they will only drag in the beer and slushies that have been spilled on the stadium floor. You should also avoid any kind of strapless dress or shirt, as you'll likely have your hands in the air quite a bit, and you don't want anything to fall out.

Concerts are an excellent time to pump up your makeup and experiment with your beauty look. We personally like to throw on lots of eyeliner—it's okay if it gets a little messy, it's very rock 'n' roll—and mascara, but skip the heavy foundation, as melting face-base is never cute. Bold or bright lips are also totally appropriate, and feel free to have fun with your hair as well.

go for
Leather jackets; vintage T-shirts; black denim or leggings; high-heeled boots; large handbags; red lips and copious eyeliner

steer clear of
Mini skirts; strapless or sleeveless tops or dresses; light colors; open-toe shoes

risky business
Long skirts, dresses, and coats; evening bags/clutches; hats

what we'd wear
Black leggings, a striped T-shirt, leather jacket, ankle boots, and our favorite big black bag

concert

corporate cocktail party

Hypothetically speaking, let's say you are the fashionista of your stuffy, conservative workplace and have to go to your annual holiday cocktail gathering. Your co-workers are very traditional—fashion-forward means anything not purchased at Ann Taylor—so it's not hard to push the envelope. The goal is to create an outfit that's appropriate, but still remains true to your personal party style. There are two solutions that will let you maintain your sense of self without making a spectacle of yourself: outerwear and accessories.

First of all, swap out your usual work outfit of a pencil skirt and blouse for a solid-colored frock. If you decide to wear a vibrantly hued dress, you'll want to make sure the hemline hits just above the knee: any longer and it's too much color, any shorter and it's not work-appropriate. If you're more into neutrals, you have a little more freedom and can pick something that ends just above or just below your knees. Essentially, you should choose a dress that can easily be transformed for a downtown party (replace corporate outwear with a little leather jacket and classic pumps with ankle boots) or turned into a more glamorous look for an uptown fete (add metallic heels, major jewels, and a little skin in the form of bare shoulders).

In our pursuit of the perfect flexible frock, we've found that the most versatile style is a strapless dress. However, for a company party you'll need more coverage in the clavicle area, so we suggest adding one of your favorite suit blazers or—even better—a tuxedo blazer over your dress. Give that business jacket a little twist by rolling the sleeves back once and pushing them up just below your elbow.

In the shoe department, you've got options galore. While we'd personally opt for something more fashionable than our typical nine-to-five pumps, in some work environments, super-strappy shoes or platforms might put off the wrong kind of "working girl" vibe, so use your own judgment.

Most corporate cocktail parties take place at night, so it's totally fine to kick up your beauty routine a little with some extra eye makeup or even a darker lip. Finally, swap out your large day bag for a classic clutch, and you're good to go mingle with Carl from accounting!

go for
Solid-colored strapless party dresses; tuxedo jackets; patent leather pumps; gray eye shadow or berry lipstick

steer clear of
Plunging necklines; long gowns; glittery or metallic pieces; daytime fabrics

risky business
Platform pumps or boots; super-strappy shoes

what we'd wear
A red strapless dress with a patent leather belt, gray and black blazer, faux croc clutch, and open-toe black ankle boots.

corporate cocktail party

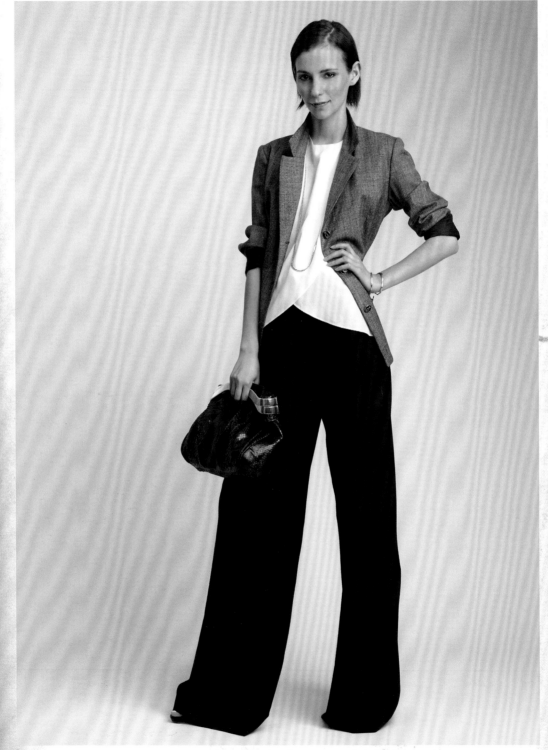

corporate job interview

corporate job interview

Whether you're doing your first round of meet-and-greets or the employment opportunity of a lifetime has just fallen in your lap, it's important to have a foolproof outfit for corporate job interviews. The goal is to create an outfit that's ultra-professional but still shows your taste level and personality. It's perfectly okay to wear a black suit, especially if that suit is well made and you enliven it with smart accent pieces.

There's little worse than an ill-fitting suit—it looks cheap, and sadly, so do you. Of course, it's completely possible to sniff out perfectly tailored garments (see Investing in Trends) without breaking your budget, just know that you should spend some time searching for truly well-made pieces. Additionally, try mixing up the pieces from your favorite suits. For example, let's say you have one black pantsuit and one gray skirt suit. Wear the black pants with the gray jacket and the gray skirt with the black jacket— you'll have twice the options!

Once you've found your dream suit and had any necessary tailoring and alterations to ensure a perfect fit, it's time to find a shirt. A crisp white button-up blouse is always a powerful and attractive choice. Plus, this classic base serves as the perfect backdrop for memorable accessories like an of-the-moment oversized clutch or a pair of vintage Chanel earrings. We also adore the contrast of a masculine suit with a feminine top, like a bowtie or gauzy ruffled blouse. It's also always appropriate to wear a solid-colored shell/silk tank under your blazer; just add a simple long necklace for a striking look.

Don't forget that your shoes will show as soon as you sit down and cross your legs, so make sure your heels are in good condition. A prospective employer will not respond well to scuffs or the lack of a heel cap. We're not opposed to a shoe or bag in a fabulous color, as long as the style is superclassic, meaning pumps with a round or pointy toe and little-to-no platform.

As for the fit of your corporate job interview outfit, make sure that your skirt is longer than your fingertips when your hands are down by your sides, but hits above your kneecap. Also, it doesn't hurt to do a dry run of your interview outfit. If anything makes you fidget, swap it for something that doesn't!

go for
Well-tailored pant or skirt suits in gray or black; bowtie blouses; solid-colored silk tank tops; brown pumps; long necklaces with interesting details

steer clear of
Body-con dresses; cleavage-baring camisoles; mini-skirts; worn-out shoes

risky business
Supersized statement jewelry; bright makeup; your highest heels

what we'd wear
A gray blazer with the sleeves pushed up, ivory chiffon shell, long, gold chain necklace, wide-leg suit trousers, and classic black peep-toe pumps

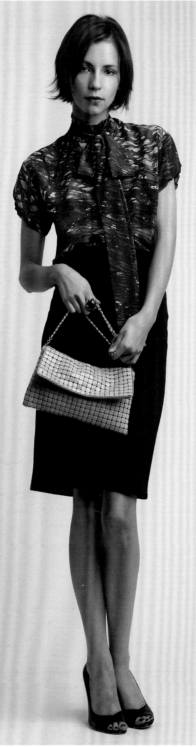

creative job interview

creative job interview

When it comes to a less corporate, more creative company, showing your personal style and taste level is key. Companies with a more aesthetic-oriented focus or point of view tend to take things like fashion and presentation seriously. You don't have to wear a suit; you don't even have to wear a blazer if you don't want. Just be sure you don't confuse creative with casual; you still need to look sharp. The goal is to create an outfit that would work for meeting your boyfriend's parents for the first time—but with more accessories!

You are not, under absolutely any circumstances, allowed to wear jeans to any interview (unless that interview takes place on a dude ranch). The same goes for T-shirts; even if it's the coolest, perfectly broken-in, most expensive vintage tee ever made, a job interview is neither the time nor the place to wear it. Choose a pretty blouse and a fantastic high-waisted skirt or pant in the season's hottest cut. Of course, we urge you to add your best, beloved, most remarkable accessories.

If your heart is set on a sleeveless top, make sure you cover your shoulders with a nice cardigan or some other sort of lightweight outerwear. While you should avoid flats—they're not quite formal enough for an interview—pick a pair of shoes that will express your personality without being too over the top. If you get to go on a tour of the office, you don't want to worry about toppling over while you walk, so make sure the heels are only modestly high.

Another one of our favorite suggestions is to incorporate at least one vintage piece—like a great handbag—into your outfit. Not only will this show your prospective new employer that you're resourceful, it can be the perfect conversation piece or icebreaker if noticed.

go for
Graphic print blouses; high-waisted skirts; cropped slacks; vintage handbags; a quirky statement ring; peep-toe pumps

steer clear of
Flats; boring suits; jeans; T-shirts; scarves; uber-high heels

risky business
Tank tops; boots

what we'd wear
A printed bowtie blouse, pencil skirt, vintage chain-link handbag, black peep-toe pumps, and an oversized blue cocktail ring

daytime wedding

Many of the guidelines we address in Black Tie Wedding apply to what you should wear to daytime nuptials. To briefly recap: it's wholly inappropriate to wear a dress that's ivory, cream, or white. A dress with a print or pattern that involves lots of one of the aforementioned colors is also verboten. Basically if half or more of the fabric is white, it's a no-no. However, unlike a nighttime wedding, now is the time to try vibrant print frocks of any length. The goal is to create an outfit that's polished, celebratory, and girly.

Day weddings usually take place outside, and if it's outside, it's probably going to be warm. This is a superb time to break out your lightweight maxi dresses (again, refrain from casual fabrics like cotton, jersey, or polyester) or even a bright colored mini dress. Though less festive, a black dress can still work, just make sure that it's on the shorter side, made of light or sheer fabric, and paired with light or bright accessories. Also, it never hurts to have some sort of auxiliary outerwear option on hand. We think a coat with cropped or three-quarter-length sleeves is a perfect choice—particularly in a bright or cheerful color—or you could even try a little lace bolero. Either way it finishes the outfit and gives you some extra polish.

When it comes to shoes, nude heels are an ideal selection, though open-toe wedges, in any color, are completely perfect too. If you're wearing a long dress, you can also go with an embellished pair of flat sandals, as it will tone down the formality of the floor-skimming hemline. You should definitely have fun with your jewelry choices: a statement necklace looks amazing with a solid colored dress, while bangles or dangly earrings will ramp up an exotic print maxi dress.

If you don't want to wear a dress, choose lightweight, light-colored fancy slacks in a silky fabric and pair it with a delicate embellished blouse and some open-toe pumps.

go for
Exotic print maxi dresses: short, bright shift dresses; silky pants; wedge heels or nude pumps; flat embellished sandals; oversized clutches, statement necklaces

steer clear of
Casual fabrics (cottons, jerseys, polyester); sequins; dark eye makeup; black shoes; big bags; white and cream

risky business
Stilettos; black dresses; white-print fabrics

what we'd wear
A loose, strapless purple mini dress, vintage pearl pendant, oversized clutch, and nude pumps

daytime wedding

football game

football game

While we wouldn't necessarily consider ourselves rah-rah girls or the super-sporty type, we've been known to have a little school spirit and show up at a football game or two. Back in our undergrad days, we went with the herd and wore team T-shirts and accessorized with other university-endorsed gear, but now that we've grown up a bit, those old outfits are no longer acceptable. The goal is to create an outfit that's stylish, appropriate, and doesn't involve a single school logo!

Much like the outfits we discuss in On a Plane (see page 134), you should aim for a look that involves lots of layers. Autumn weather is always a bit weird, so it's important to be prepared to go from a warm afternoon tailgate to a brisk nighttime fourth quarter. Comfort is key too, as football games always seem to involve a lot of unanticipated moving around, like walking from the parking lot to your seats and up and down the stadium stairs.

Start by grabbing some comfy cute jeans, preferably a pair with a little bit of stretch, for easy sitting, and in a dark rinse that won't show spills. We like a mid-rise boot-cut or flare style ourselves because the moderate waist ensures you won't accidentally flash the people sitting behind you, while the wider leg will drape over your shoes nicely.

Don't get fancy with your footwear; we suggest wearing a cool, broken-in pair of sneakers, like classic black lace-up Converse or slip-on Vans. Flat boots are fine too, but don't wear a pricey pair, as you never know how much spilled beer you might encounter.

As for the rest of your ensemble, we like to nod to fall by wearing a cozy plaid shirt. If you'd like to subtly show your spirit, pick a plaid that features one of your school's colors. Don't bother tucking it in; this is an informal occasion so just wear it in a relaxed way. For additional warmth, layer a lightweight little leather jacket over the plaid shirt and grab a slouchy beanie or knit cap. Nothing in your look should be high maintenance in any way—especially your accessories—so we like to wear a handbag with a long shoulder strap. It gives us peace of mind to know where it is at all times, and it keeps our hands empty so we can high-five and hold a beer simultaneously!

go for
Layered tops; across-body bags; wool hats; tennis shoes

steer clear of
Face paint; oversized team T-shirts; high heels; dresses or skirts

risky business
Boots; tight jeans; loads of jewelry

what we'd wear
A soft plaid button-up, little leather jacket, boot-cut jeans in a dark rinse, broken-in lace-up sneakers, a warm, wooly, slouchy cap, and a simple cross-body bag

high school / college reunion

Though high school/college reunions aren't an everyday occasion (praise be), they do pop up like clockwork every few years. What you choose to wear to said reunion is always quite revealing and trumpets quite a message. The goal is to create an outfit that conveys who you've become—not who or what you used to be or what you wish you were.

Our plan of attack starts with finding a dress or top-and-skirt combo that is both professional and fashionable, then adding a killer pair of shoes. While it's better to err on the demure side with your outfit, feel free to go all out with your footwear and wear a cherished pair of drool-worthy, super sexy heels. Also remember that demure doesn't mean matronly, so it's perfectly fine to show your figure, just not too much skin. A thin, snug three-quarter-sleeve sweater and a pencil skirt would work perfectly well (it highlights your shape while still remaining technically modest) as would your favorite dress.

Again, we'd like to reiterate that this isn't the time to wear anything extremely casual or inappropriately dressy. Though we think it's important to take your outfit up a notch from the typical jeans-cute-top-and-blazer look, if this is how you feel most comfortable, we'll give you a grudging go-ahead. On the flip side, please know that sequins are never necessary for a reunion. It's just a get together with people from the past, you're not reliving prom. Other key things to avoid: anything overtly sexy, crazy prints, and super-bright colors—all are trying too hard. Jewel tones mixed with patent leather and some cool jewelry is a smarter choice. As we said in Casual Date (see page 107) and Creative Job Interview (see page 115), you should use thoughtfully chosen accessories to communicate your taste level and point of view.

go for
Jewel-tone dresses; strappy black pumps; personality-revealing jewelry; metallic accents

steer clear of
Prints and bright colors; sequins; denim; low-cut tops, short hemlines; bandage dresses and skirts

risky business
Embellished duds; leather; red lips

what we'd wear
A purple silk top, gold and black skirt, emerald green clutch, and studded, patent leather, high-heeled sandals

high school / college reunion

hot night out

hot night out

For all the times we've mentioned the word "modest," listed body-conscious items as "risky business," or told you to go easy on the makeup, when it comes to going out with your friends on a Friday night—we take it all back! The goal is to create an outfit that's a bit experimental, takes a few risks, and includes a new fashion-forward trend.

Most importantly, we want to get you away from the boring going-out uniform. You know the outfit we're talking about: a silky, sexy camisole, tight pair of blue jeans, and high-heeled sandals or pumps. YAWN.

We know you love jeans, but please try and stay away from them on this fun night. If you must wear them, at least mix it up by trying a black or gray pair instead of blue. Why not style those sexy camisoles with a great pair of black shorts, either with or without tights, or cropped black pants with strappy bondage-style shoes? If you're a T-shirt kind of gal, you can still wear this unfussy favorite, just try it with different bottoms. We love an easy white tee worn with some cool jewelry and a body-conscious or little leather skirt.

As for your outerwear, we adore either a shrunken denim jacket or a little leather motorcycle jacket—either piece will add a bit of casual cool to your outfit. Whatever the case, make sure you have a stunning pair of shoes—the higher the heels, the better—and make sure you can dance in them!

You should also get creative with your beauty look on a Hot Night Out. Try a dark cat eye, vibrant eye shadow, or even colored mascara. For lips, go glossy, nude, or deep wine. Definitely experiment and test-drive a hair style you pulled from a magazine or recently spotted on a celebrity. Whether it's curls, braids, or adding a hair accessory like a feathered or jeweled pin or headband, now is the perfect occasion to play around.

We'll trust you to pick out your edgiest accessories and jewelry and hope that you don't insist on carrying your normal day bag. Ideally, you'll pull out an evening bag or clutch instead. Evening bags aren't as seasonal or trend-driven as regular handbags, so it's worth investing in a great one every couple of years. You'll get the most wear out of a bag in black or gray, or one with a metallic/embellished finish.

go for
Leather skirts; denim jackets; black shorts; sparkly tops; high-heeled boots or pumps; interesting makeup; trendy hairstyles

steer clear of
Day bags; conservative hemlines; modest necklines

risky business
Work wear; jeans; flats

what we'd wear
A sparkly, embellished tank, black dress shorts, stack of bangles, and royal blue open-toe ankle boots

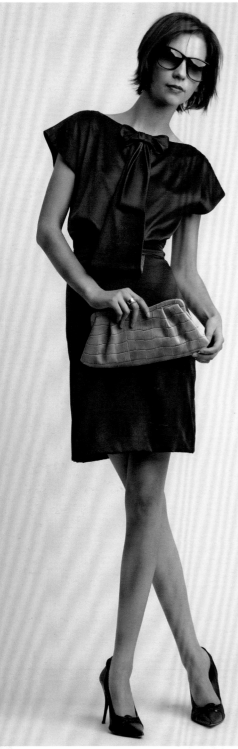

ladies luncheon / shower

ladies luncheon/shower

Ladies luncheons and bridal or baby showers are very girly and happy occasions, so your outfit should have a similar spirit. The goal is to create an outfit that's similar to what you'd wear to a daytime wedding, but a bit more casual. Dresses are always top choice for a female-focused fete, though we also like a skirt-and-top combo or a light-colored silky slack. As you search for your prospective outfit, please keep in mind that the darkest colors you should consider are jewel tones, and please skip black altogether! A light or bright color will fit in with the feminine setting a bit better.

For outerwear, we like either a cute, cropped jacket or a snug blazer, but even a thin cashmere cardigan will do the trick. The luncheon or shower is one of the few occasions where you can get away with flats, but be warned that most women will wear heels or wedges. Unless you're on the tall side, or just loathe heels, you might feel more in sync with everyone else if you wear a shoe with some height. You should further accessorize with a pair of stylish sunglasses and a bright clutch.

Since femininity is the name of the game for this event, make sure your makeup is evenly blended and that your nails are well-groomed with a pretty shade of polish. If you're in doubt, it's best to err on the natural side; it's better to be underdone than overly made up.

On that girly note, a quick reminder that fidgeting with one's outfit is certainly not conducive to ladylike behavior, so make sure that you choose a dress or skirt that is easy to sit in. There's lots of movement at these events—standing for mingling and hors d'oeuvres, sitting for lunch, moving to another area for presents—so whatever you wear, wrinkle-resistant fabrics are a smart choice. There's no point in going to all the trouble of getting dressed up if you're going to look like a crumpled dinner napkin before the event's half over.

go for
Colorful dresses; bright clutches; chic sunglasses

steer clear of
Short skirts; black garments; chipped nails; jeans

risky business
Flats; linen, silk, or other fabrics prone to wrinkling

what we'd wear
A lightweight, wine-colored dress with a bow detail, mustard clutch, and black, pointy-toed, low-heeled pumps

lazy sunday

For those of us with jobs that require us to "dress" on a daily basis, Sunday can become the most difficult day to get ready. Even if the only thing on your schedule is a morning full of errands or brunch with some girlfriends, finding the right casual ensemble can be stressful. The goal is to create an outfit that doesn't look like it's trying too hard and is comfortable from head to toe. If it has to be dry-cleaned, it's probably not right for a lazy Sunday.

We like to raid our boyfriends' closets and borrow their oxford shirts, which look great with the sleeves rolled up and worn with a pair of skinny jeans and loafers. Another favorite look is to throw on a long cable knit cardigan over a lacy tank, then add some leggings and a broken-in pair of Converse sneakers.

If you're afraid you look too casual, sometimes just adding a vibrant-print scarf will tighten up an otherwise relaxed combo. Whatever you're doing, keep things fuss free, meaning no super-tightly cinched belts, and please overlook your tightest jeans. Other than that, any denim style is appropriate for a lazy Sunday: wide-leg, boot cut, even distressed, cuffed, easy-fit boyfriend jeans.

If you don't feel like doing your hair or your makeup, make that work for your outfit! Instead of re-straightening your hair, why not throw on that saggy wool hat you've wanted to try instead? Also, don't forget the lovely power of sunglasses to camouflage a nude face! Just grab a pair of aviators and go, because when it comes to your makeup, less is more. There's nothing worse on a Sunday morning than seeing that girl at the grocery store in full-blown eye makeup. Give your skin a break and focus on your nails instead by taking a little time out to give yourself a mani-pedi.

go for
Oversized button-ups; low-top tennis shoes; distressed denim; long cardigans; aviator sunglasses; wool beanies; patterned scarves

steer clear of
Excessive makeup; high-waisted skirts; heels

risky business
Tight jeans; leather or pleather

what we'd wear
A men's button-up shirt, long knit vest, boyfriend jeans, and a pair of lace-up sneakers

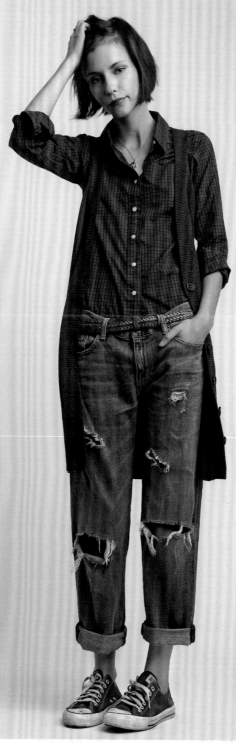

lazy sunday

meeting the parents

Meeting your significant other's parents for the first time can put even the most calm, cool, and collected girl into a panic. The goal is to create a look that is respectable (for the folks), cute (for your fellow), and cool (for yourself). We know there are lots of competing forces at work here, but don't give in to the pressure! Though it might sound counterintuitive, just wear whatever you like. Seriously! What's the point in dressing like an angelic Puritan if you're really a leather leggings-wearing drummer? If the meet-and-greet goes well, they'll get to know the real you anyway, so don't try to present yourself as something you're not.

A few tips: when it comes to shoes, avoid any that you would consider wearing to a nightclub. Your footwear should still show your taste, but they should be a little more modest—like something you'd wear to work! We think it's important to make a little extra effort, which means skipping jeans. Sadly, denim just sends a message to the parents that they're not worth the effort of dressing up for.

Much like the workplace, this is not the time for short skirts or plunging necklines. Don't wear anything strapless or too revealing, and choose a smart piece of outerwear, like a shrunken blazer. Try to avoid an all-black outfit, and throw at least one vibrant piece into your look. On that note, please wear at least one accessory that shows your personal style—like a trio of bangles or a multi-strand necklace—but don't get experimental. The same principles apply to your beauty routine, so save the trendy new hairstyle or red lipstick for another occasion.

Also, don't forget to take into consideration where this parental rendez-vous is taking place. If you're going to their home for a casual weekend brunch, go for flats so that the mom doesn't feel underdressed. If it's a five-star restaurant for their anniversary party, kick your whole look up a notch so they know you care.

go for
Bright shift dresses; smart blazers; soft, feminine tops; full skirts; camel-colored trousers

steer clear of
Red lips; spike heels; corset tops; lace tights; strapless dresses

risky business
Boots; denim; leather

what we'd wear
A bright yellow dress, cropped black jacket, of-the-moment taupe handbag, and low-heeled, patent leather, peep-toe ankle boots

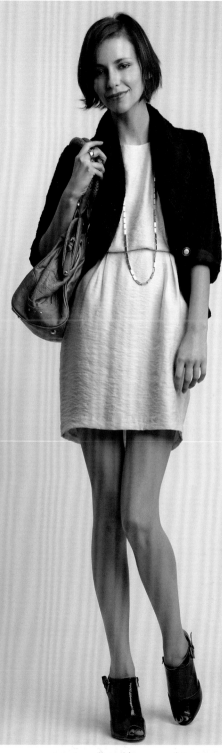

meeting the parents

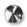
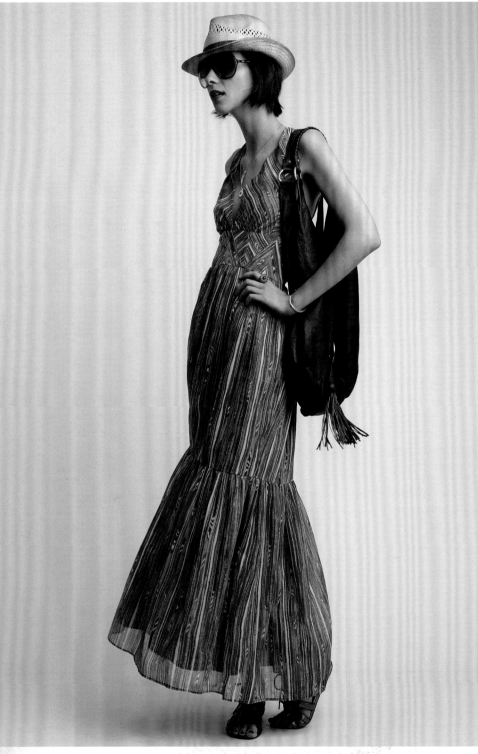

music festival

music festival

When you're getting dressed for a music festival, it's important to use your common sense, as misguided choices can ruin your whole experience. The goal is to create an outfit that celebrates your personal style, but is still practical for the occasion. For most big summer shows, the foundation of your look should be a lightweight sundress—either maxi length or short—and, since you'll be on your feet all day, some really comfortable sandals.

If you absolutely refuse to go flat, then go for an espadrille or a wedge sandal. Returning to the dress: you should choose something sleeveless or strapless and make sure it doesn't have any intricate cuts that could leave you with crazy-looking tan lines.

Sunglasses and a floppy hat are two must-haves for all festival-goers—sun damage is never fashionable. Choose a hat that can easily be folded up and stuffed into your big tote when the sun goes down. As it does get cold at night, use that oversized bag (shoulder strap preferred, so your hands are free) to carry a cardigan and some type of lightweight scarf. You can either wear the scarf around your neck, on your head to cover up hat hair, or as a makeshift blanket.

Obviously you need to check out the weather before you go. If it looks like rain, you might want to swap out your sandals for a pair of wellies, à la Kate Moss, and avoid anything white or super-sheer that could become see-through in the rain. If it's going to be a scorcher, choose an airy or generously cut skirt or dress, because tight clothes equal sticky hot clothes.

go for
Boho maxi dresses; denim cut-offs; oversized totes; delicate gold jewelry; tortoiseshell sunglasses; brown sandals or Wellington boots; floppy sunhats

steer clear of
Dresses or tops with cut-outs; pants, heavy makeup; high heels

risky business
Dresses with sleeves; short dresses; white T-shirts or dresses; wedge sandals

what we'd wear
A tribal print maxi dress, slouchy navy leather bag, bronze flat sandals, straw fedora, and oversized aviators

new year's eve

There's so much pressure and planning that surrounds New Year's Eve that the night rarely lives up to our expectations. The best part of the night—for us anyway—is getting ready! The goal is to create an outfit that has a little more glitz and glamour than usual and to have fun with your look.

A little cocktail dress, especially one with some shine and sequins, is the quintessential New Year's Eve outfit. If it's cold where you live, warm up with a pair of black opaque or even lace tights, wrap yourself in a little faux-fur stole, and you're set!

While we love party dresses, we are also quite keen on the idea of a pair of silky dress pants worn with a sequined tank, or even a sequined or shiny brocade skirt with a simple tank or tee. It's a little unexpected and a totally refreshing look.

Another route you can take is to wear a simple little black dress and merely glam up your makeup, hair, and accessories. Since you've saved money by wearing a dress you probably already own, you can afford to splurge on getting your hair professionally blown-out or picking up a few inexpensive and glitzy pieces of jewelry (hello, Forever 21).

We also suggest that you try something new with your beauty look, like a copper smoky eye or electric violet eyeliner, or even a deep red lip. After all, it's a new year, why not show off a new you?

go for
Sequin skirts; faux-fur jackets; silk hostess pants; vintage costume jewelry; dark red lipstick; lace tights; lurex

steer clear of
White; summery fabrics; uncomfortable shoes; large bags

risky business
Long gowns; too-tight skirts

what we'd wear
A blue sequined miniskirt, soft white T-shirt, black tuxedo blazer, rhinestone bracelet, black lace-up ankle boots, and a patent leather bow clutch

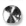
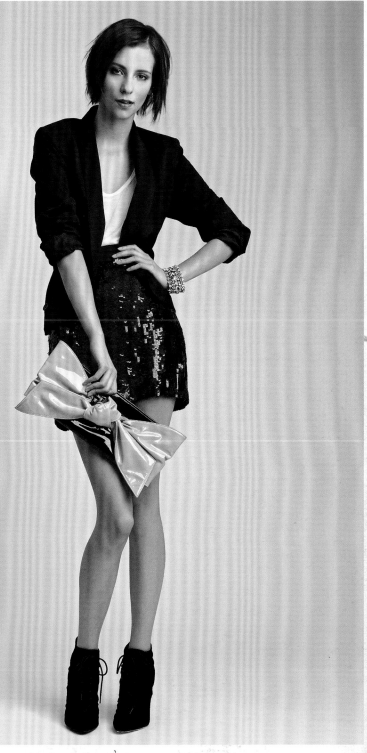

new year's eve

on a plane

Every time we're in an airport, we're startled by what our fellow passengers decide to wear: sweat suits, dog collars and chain jewelry, sheepskin booties, and worse. But we know that air travel is difficult enough, so don't worry, we're not going to ask you to dress up. Instead, just put a tiny amount of thought into your travel outfits! The goal is to create an outfit that's pulled-together, sophisticated, and completely comfy.

The first thing we consider when putting together a travel outfit is fabric. There are so many soft and wrinkle-resistant materials out there, so skip the linen and go for thick cottons and cashmeres instead. You want to be prepared for any temperature changes, so layers are key as well. A lightweight scarf is always a chic accessory and can be quite handy when the plane's air-conditioning gets cranked up. Plus, it can also double as a pillow if you roll it up!

Socks are a necessity these days with all the safety regulations. You don't want to find yourself walking barefoot through security in everyone else's foot funk, ew! Boots can be great, if they're easy to slip on and off, just make sure they aren't too high, as super-tall boots can make for uncomfortable leg crossing. If boots aren't your thing, try low-top lace-ups, ballet flats, or driving shoes. If you insist on being taller when flying the friendly skies, skip the stilettos and go for wedges.

Don't forget that other key accessory: sunglasses. If you throw on some of-the-moment shades, you'll instantly bring your basic outfit up a notch and cover your dark circles if you're taking the redeye.

go for
Long sleeve T-shirts, cashmere sweaters; leggings (with a long shirt); relaxed fit or stretchy jeans; lightweight scarves; socks; slip-on shoes; sunglasses

steer clear of
Excessive jewelry; heavy makeup; sweat suits; tight jeans; small bags; linen; heels

risky business
Hats; boots

what we'd wear
Distressed jeans, long-sleeve T-shirt, tan cardigan shawl, gray scarf, dark sunglasses, and tennis shoes

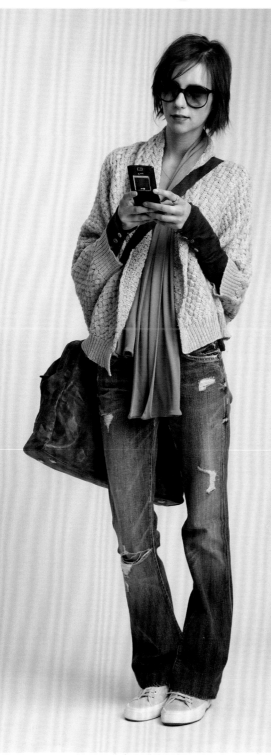

on a plane

somber occassion

somber occassion

No one wants to think about going to a funeral, let alone ponder what to wear, but when the inevitable comes up, it's good to have a plan. The goal is to create an outfit that's appropriately somber and blends in, while still looking chic. While it's customary to wear black, you can also wear navy or charcoal gray.

Start with a simple, modest black dress or skirt and blouse. If the cut is not conservative enough and the hem hits above your knees, you can add a pair of dark tights in gray, burgundy, or black. It's also important to remember to keep your shoulders covered, especially since most funerals are held in religious venues. If you only have a sleeveless dress, add a cropped black coat for some much-needed coverage.

This isn't the time to be trendy with your accessories; think classic instead—like a black quilted bag—and skip the jewelry. Wear basic, dark pumps (no flats, unless you're sixteen years old or younger) and don't forget a pair of oversized dark sunglasses to hide your eyes. Stay away from any sort of print, though a faint pinstripe is fine, and wear your makeup as naturally as possible.

go for

Black cap-sleeve dresses; charcoal skirts, black button-up blouses; quilted chain-strap handbags; oversized sunglasses; dark tights; simple black heels

steer clear of

Prints and patterns; bright colors; white; trendy jewelry; flats

risky business

Hats

what we'd wear

A black shirt-dress, skinny patent leather belt, quilted bag, oversized sunglasses, and medium-heeled black pumps

warm weather vacation

The best thing about resort/vacation wear is that, for the most part, it's not so seasonal or trendy that it quickly becomes dated. Global prints and white sundresses never go out of style; but having a couple of standby looks doesn't mean you can completely slack on your personal style. The goal is to create a few festive outfits that can easily transition from the sand to the shore.

When going on a warm weather holiday, there are a few things that we think every fashionable woman should pack. A bright caftan is a key piece, just make sure it's long enough to go over a bathing suit and brief enough to wear bloused up over a pair of shorts. Denim cut-offs are also a smart selection. If you don't want to buy a new pair, just cut an old pair of easy-fit jeans or scour your local thrift store for some worn-in Levi's.

It's always wise to pack a long dress in a bright color or pattern, because you can wear it sightseeing during the day with flats or for dinner at night with wedges. Outerwear-wise, you should bring a denim jacket or a neutral-colored lightweight cardigan for when it gets chilly at night.

We also suggest that you bring a long statement necklace, preferably one that's inspired by the locale, and a fabulous dark pair of sunglasses—the bigger the better. Don't forget to grab a lightweight tote that's big enough to hold your sandals if you go on an impromptu walk on the sand, as well as any souvenirs you might pick up on your stroll.

As for your shoes, you should pack at least two pairs of sandals (brown, nude, black, metallic, or colored) and one pair of sandal wedges for nice dinners. Additional accessories can include a bangle or two, but for the most part, go light on the jewelry. Your beauty routine should also take a vacation during this time. Just pack a little bronzer, blush, some natural-colored lip gloss, and a little mascara for night!

go for
Bright colored caftans; maxi dresses; white sundresses; shrunken denim jackets; denim cut-offs; nude sandals; lightweight tote bags, long tribal necklaces; bronzer

steer clear of
Eye makeup; bandage skirts or dresses; high heels

risky business
Black; fine jewelry

what we'd wear
A silky purple and pink tunic, vintage denim cut-offs, flat silver sandals, a long fabric and bead necklace, and a brown leather tote

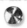

warm weather vacation

chapter

MOST FREQUENTLY ASKED STYLE QUESTIONS

most frequently asked style questions

Much like Ann Landers or Abigail Van Buren (aka Dear Abby), we sometimes feel like we're running an advice column. Each month, thousands of people write in to WhoWhatWear.com asking specific questions about how to wear the latest looks, as well as whether specific trends (like skinny jeans or nearly-black nail polish) are still acceptable. While we try to respond to as many of them as possible via our website, we decided to address some of those fabulous frequently asked questions here. After all, great minds think alike, so if these are the most popular queries, we figured lots of people might appreciate the answers!

1 How do I know which sunglass shape is best for my face?

When shopping for sunglasses, our general rule of thumb is pretty simple: figure out your face shape and then find frames that are the opposite! It's weirdly contrarian, we know, but that's how it works! That means round-faced girls should look for sunglasses with horizontal lines, as this will add angles and lengthen the face, so try rectangular styles that are wide at the temples. Square-jawed gals need something that softens their angles, so the best choice is a style with curving lines, like oversized ovals or cat-eye frames. Heart-shaped honeys should balance out their stronger foreheads with something that draws the eye downward, like an aviator, and avoid wide frames.

Oval-faced folks are super-lucky and can basically wear whatever they want—how fun!—so feel free to experiment. Also, this should probably go without saying, but don't forget to check your Celebrity Doppelganger for suggestions about the right shades shape. As you know, celebs love wearing their sunglasses and they always have the latest styles!

2 *How do I add bright color to my wardrobe?*

Around the Who What Wear office, our favorite way to bring in a statement shade is through an accessory. One easy option is to pick a bright pair of shoes and then wear them with a neutral-colored outfit, or even basic black. Neutrals like gray, white, tan, or taupe are always in style and they look particularly chic when worn with a pop of color, like a bold cherry-red bag.

Whatever key accent piece you pick, that should be the only item in your outfit in that exact shade. In other words: don't upstage the splendor of your electric turquoise pumps by wearing them with a similarly hued shirt—ew! Just the idea alone makes our matchy-matchy alerts go off—never a good thing. If you simply must add another statement color to your outfit, make it a small piece, like a ring or a scarf. Just be judicious about whatever you add; too much bright will give anyone a fright!

3 *How do I wear shorts without looking short?*

Brevity may be the soul of wit (and lingerie, to mix Bill Shakespeare with Dotty Parker), but it's certainly not a beloved quality for legs. Fret not, dear readers, because we've got a trick for making even the most Lilliputian limbs look downright lanky. Three words: skin tone shoes.

If you wear shoes in a shade that's similar to your skin color, it tricks the eye into thinking there's nothing there. The shoe will appear to blend in to your skin, therefore elongating the line of your legs! And what goes well with long legs? Shorts, of course! That said, we also suggest staying away from any shoes that have ankle straps, or styles that cover the tops of your feet completely, as they will break up that long line you've worked so hard to fake! Instead, try a low-cut pump for night or a simple pair of slingback sandals or wedges for day—any of these choices will work!

4 *How do I pull off a dark lip color for day?*

As we've said before, you can wear almost any style or beauty look you want; it's just a matter of making it appropriate for your figure, face, budget, and lifestyle. When it comes to lip color, we're all lucky. These days, there are so many different textures and formulas available that something's sure to work. For example, while a seriously rich shade of opaque lipstick isn't necessarily appropriate for day—it's really more proper for cocktail hour and beyond—a sheer version of that bold color will definitely work. Just pick a product with a lighter formula, like a lip stain or even a gloss, and you'll get the effect you're after while still looking correct.

The other nice thing about lip stains is that they're buildable and adaptable, so you can add as much or as little as you want, and most shades will work on a range of skin tones. For your day look, just put a little stain on the tip of your index finger and dab it on the center of your lips, fanning out to the corners. If you want a little more texture, slick some lip balm, or even a coat of clear gloss, over the stain. Whatever you do, please just skip the red lip liner; this is neither the time nor the place for it!

5 What's the secret to vintage shopping?

You should look at going vintage shopping a little bit like you're going into combat. We've yet to see a thrift store or vintage boutique that didn't threaten to overwhelm us, so having a plan of attack is imperative. Before heading out, decide what you're looking for that day, as this will help you stay focused and ensure that you're not sidetracked by unnecessary distractions. What do you want to bring home from this expedition? A seventies-inspired kaftan? Little leather motorcycle jacket? Chunky gold jewelry? Figure it out: as G.I. Joe said, knowing is half the battle.

Even if you don't have such a specific product-oriented plan, there are still ways to organize your shopping. When you're browsing, keep an eye out for patterns and fabrics you like. If something catches your eye, pull that piece out for a closer look and fire up your imagination. Visualization is key: just because something looks like it's the wrong length, or even the wrong size, don't let that stop you. Almost any garment can be tailored to fit your body (hemmed, cropped, nipped in) or altered to achieve a desired style (remove sleeves, narrow the cut, add a belt).

No matter what your strategy is, always keep your quality radar switched on. Inspect your potential buys thoroughly for stains, paying careful attention to the fabric under the arms and around the neck, as these cannot always be fixed. Also, make sure that the lining of your garment is intact, as that is an expensive and annoying repair.

6 What are the five key pieces to any wardrobe?

Much like building a house, it's important to give your wardrobe a strong—and fashionable—foundation. If you invest in thoughtfully considered, classic pieces, you'll have a great wardrobe base to work with, which makes getting dressed so much easier.

So how does one go about creating said solid infrastructure? Well, first and foremost, start with a well-made pair of America's favorite pants: the denim jean. Don't worry about picking the trendiest or coolest style, instead just find the pair that looks best on your body. Dark-wash denim with little-to-no distressing is always a good choice! It's best to choose a classic cut, like slim or straight leg, which will allow you the most versatility when it comes to the shoes you choose.

Each season you can make your investment jeans feel current by updating your outfits with some trendy, inexpensive pieces.

As for other key pieces, we suggest investing in a black quilted-leather chain-strap bag à la Chanel. It's a timeless style that looks just as chic in spring as it does in fall. Also key: the little black dress, of course! We'd go for either a bandage-style dress or one made from black lace, as both are fashionable while still remaining completely classic. You should also find a crisp white button-up shirt, ideally something with a menswear-inspired style. A simple shirt like this is incredibly versatile; it will look great on a casual day with jeans and of-the-moment accessories or you can dress it up by tucking it into a little black skirt.

Finally, always hold on to a well-tailored black tuxedo jacket, as it is one of the prime pieces of outerwear you can buy (other classics include: the trench, the denim jacket, and the little leather jacket). In addition to giving any outfit a bit of Yves Saint Laurent chic, the tux jacket can easily be dressed up or down. It looks smart with a T-shirt and a pair of jeans and adds some sharp style to a fancy floral party dress.

7 How do I shop at discount stores?

The most important thing to keep in mind about discount stores is that, as a general rule, everything in stock is a minimum of two seasons old. Since the goods are going to be a little bit dated but not old enough to be retro, it's best to search for things that are true classics. Look for key pieces in neutral colors, dateless prints like stripes, polka dots, and florals, and "traditional" shapes such as body-conscious or menswear-inspired ones—basically anything that doesn't have a telltale seasonal sign.

The same governing rules hold true for shoes: stay away from anything trendy. Instead, stick to leather or patent leather stiletto pumps with round or pointy toes and avoid anything overly embellished or chunky. Also, keep your eyes out for irregularities, especially when it comes to sizing. Items are often mismarked, so definitely take the time to try everything on. Finally, curb your bargain-hunting excitement and focus on what you're spending—not what you're saving. By emphasizing cost, you won't end up going home with unnecessary items!

8 How do I clean out my closet?

We're not going to lie: tackling your closet is a tough job. Don't attempt this if you're in a sentimental mood (you'll save everything, so it's pointless) and remember that you should be tough—heartless even. Trust us, it's for a much greater good! First, you're going to have to try everything on. Go through your closet methodically and separate your clothes into four different piles: keep, giveaway, toss, and sell/swap.

KEEP the items you wear most frequently, of course. Remember, if you haven't worn something in a year and a half, it should not be in this category! But hang on to any beloved designer pieces (they will come back in style, as we discussed in Cycle + Celeb = Trend), as well as anything that you need to repair.

GIVE AWAY inexpensive pieces that don't fit, even if you swear you're going on a diet tomorrow, or those cheap thrills that you no longer wear, including T-shirts, shoes, outerwear, and pants. Sure, it might have been wonderful at some point, but if it's cheap and you haven't put it on lately, get it out of your closet.

Toss anything that is irreparably damaged. If it is stained or has unintentional or unfashionable rips, holes, or tears, it belongs in the garbage.

SELL/SWAP any designer duds you don't care for any longer—expensive jeans, uncomfortable shoes—including anything that doesn't fit. Either take them to a consignment shop or trade with friends—whichever it is, removal is necessary!

Now that you're done with the closet, it's time to go through your drawers! Ruthlessly sort through their contents, as you can use that free space to possibly relocate things from your closet (like T-shirts or sweaters) if you're still short on room there.

Last but not least, it's time to clean up what's left! Return anything that made the Keep pile to its rightful place in your closet. If you want to treat yourself to matching hangers (the thinner the better; we like the velvet-covered hangers at huggablehangers.com), we fully support that choice. Organize your closet by category—tops, dresses, pants—and finally, group those sections by color.

We know this sounds ridiculously anal retentive and tedious, but now you've set up an amazing system! You'll never waste another moment searching for your favorite black shirtdress! And, best of all, we promise that this highly catalogued closet of yours will cut your morning wardrobe deliberations in half, hooray!

9 What's the best way to wear belts?

There are so many fun and fashionable belt options available right now, so it's important that you experiment! That said, regardless of their style, all belts fall into one of three basic width categories: skinny belts (1" or thinner), medium belts (1.5" or thicker), and wide belts (3"-plus). Skinny belts are best worn cinched over really lightweight pieces—like a dress, cardigan, or a combination of the two. Thin fabrics are key here, so if you have a delicate item, like a long blouse worn with pants or a skirt, go for an equally svelte belt at your natural waist.

Medium-width belts are definitely the most versatile option of the three styles. You can wear them traditionally looped through jeans or trousers or low-slung to rein in a loose dress or tunic. Since you need it to fit at both the mid-waist and on the hips, we suggest buying a slightly bigger size that accommodates both.

Wide belts (aka super cinchers) are the most difficult to wear, simply because they make a statement! These belts look incredible when worn over a dress or with a tucked-in-top-and-skirt combo, as they will create a figure-emphasizing silhouette. We're pretty sure it goes without saying, but super cinchers should be worn at the natural waist.

10 How should I be wearing boots?

Boots are deceptive: they seem relatively foolproof, but it's possible to wander into tricky territory rather quickly, so it's best to have some governing guidelines. First of all, let's talk about boots and jeans. If you are planning on going for the Parisian pedestrian look (skinny jeans tucked into boots), start by opting for slim-cut pants in the same color tone as your boots. If you wear light-colored jeans with dark boots—or vice versa—it can chop up the line of your leg and make you look short and stumpy. As for the shape of the heel or toe, it's really up to you; skinny or chunky heels are fine, as are pointy or round toes.

However, if you want to wear your boots under your jeans, we recommend that you choose a pair with a sturdy heel and a round toe, as pointy boots with skinny heels can make you look a bit prissy and fussy, kind of like a Pomeranian. Also, to avoid having any lumps at the calf, make sure that the shaft of the boot isn't too tall and that it fits snugly.

Boots also can look fantastic with skirts or a dress, preferably if you wear them with semi-opaque or fully opaque tights! Tights will help create the illusion of long lean legs—select a hue that's in concert with your boots—while adding some sophistication to your outfit. Sadly boots and skirts/dresses with bare legs can look a little tarty and cheap. If the weather won't allow for tights, or you just insist on wearing bare legs, please pick a boot in a color that's similar to your skin tone (just like in Question 3, you don't want a high-contrast shoe) and avoid any styles with super-high platform heels.

chapter

10

STAYING
AHEAD
FROM
HOME

staying ahead from home

With the help of a few resources, anyone can be a fashion-forward favorite in their community, no matter where they live. You no longer have to travel to large cities or fashion capitals to stay ahead of the trends; all you need to do is acquire a few subscriptions! In addition to various international fashion magazines, don't miss out on all the fantastic websites currently creating content, as they'll keep you on-trend and in the know wherever you go.

FASHION & BEAUTY NEWS WEBSITES

FASHIONISTA.COM—If you're looking for independent media coverage, check out the always-friendly Fashionista.com. It's a blog-formatted site, much like Gawker.com and Jezebel.com, which shares breaking news and gossip in the fashion industry.

FASHIONWEEKDAILY.COM—The tongue-firmly-in-cheek daily fashion website is like the snarky little sister of Style.com and WWD.com. In addition to fashion week calendars, show coverage, party photos, and recaps, the site also details the latest happenings of the fashion crowd and gossip about the fashion media world.

STYLE.COM—The go-to destination for an unadulterated dose of runway fashion is definitely Style.com. The Condé Nast–owned site showcases videos and photos of current and past runway collections (as far back as 2000), backstage and front-row coverage, trend reports, accessory reports, and party pics.

THEFASHIONSPOT.COM—This invite-only website offers breaking fashion and beauty news as well as the ability to interact with other fashionable members while sharing photos and information throughout their vast forums.

WWD.COM—If you're looking for the latest scoop about the "business" of fashion, from new designers and campaigns to sales and statistics, WWD is a must-read. This fashion trade publication also includes a classified section and insider information about the who's who of the fashion media world.

FASHION & BEAUTY INSPIRATION WEBSITES

FACEHUNTER.BLOGSPOT.COM—This street-style site is run by the Swiss-born London-dwelling Yvan Rodic and features amazing shots of fashion-forward Europeans and international trendsetters.

GARANCEDORE.FR—Much like TheSartorialist.com, this site is helmed by a Paris-based photographer, illustrator, and fashion watchdog, Garance Doré. We adore Doré's brilliant eye and winsome photos.

JAKANDJIL.COM—The creation of fashion photographer Tommy Tom, JakandJil.com spotlights the outfits of attendees at various fashion weeks, including models, editors, and stylists. Fashion icons like Carine Roitfeld (editor of *Paris Vogue*), Emmanuelle Alt (fashion director of *Paris Vogue*), and Irina Lazareanu (top model) detail their most stylish outfits, piece by piece, for this site.

LOOKBOOK.NU—A user-generated website featuring fashionable everyday outfits on real people throughout the world.

THESARTORIALIST.COM—A highly respected blog by New York City–based photographer Scott Schuman featuring fashionable real people on the streets of Paris, London, Italy, and New York.

WHOWHATWEAR.COM—Our daily updated online magazine shows the latest trends in fashion and beauty, including photos and how-to videos.

ONLINE FASHION RETAILERS

AMERICANAPPAREL.NET—If you're looking for fashion basics such as T-shirts, leggings, and sweats, there's no better place than American Apparel. You can't beat the quality or the price.

BAKERSSHOES.COM—BakersShoes.com is stocked with shoes, shoes, and more shoes! The site features styles inspired by your favorite (past and current) runway collections.

BEBE.COM—One of our favorite resources for of-the-moment, trend-driven pieces. They always stock runway-inspired clothing and accessories at completely affordable prices.

FOREVER21.COM—This trendy bargain store knocks off the latest and greatest trends and pieces the moment they hit the runways.

LUISAVIAROMA.COM—High-fashion fans take note: If you're craving hard-to-find Balmain pants, the sexiest Givenchy shoes, or the next "it" bag, start your search here.

MATCHESFASHION.COM—This London-based chain of high-fashion boutiques offers an equally smart online retail experience. Stocked with the most covetable pieces from top designers, it's a great place to drool over runway looks galore.

NET-A-PORTER.COM—If you're looking for an extremely vast and well-curated selection of luxury designer goods (including most ready-to-wear designer collections and accessories), definitely check out NAP.

OFFICE.CO.UK—A cheap and chic British shoe retailer that ships to the United States.

PIPERLIME.COM—From the great people at The Gap and Banana Republic, Piperlime.com is a large shoe and handbag store featuring the latest trends as well as "picks" from key tastemakers in the fashion community.

REFINERY29.COM—Refinery29.com is a virtual mall comprised solely of the best indie boutiques. It's a great destination-shopping site, as it features fashion from many of our favorite brick-and-mortar stores.

SEENON.COM—This website shows you similar clothing to what you've seen on recent television shows and allows you to purchase with one single click.

SHOPBOP.COM—Arguably the largest (and best) one-stop retailer for women's contemporary fashion, including a massive inventory of clothing, bags, shoes, and other accessories.

SHOPSTYLE.COM—This website is essentially a search engine specifically for clothing and accessories. Just type in the item or brand you are looking for, and it will sort through tons of online stores to bring up what you want. It's a great way to find the best prices and track down in-demand pieces.

TOPSHOP.COM—The UK's famous high-street store online, featuring ultra affordable cutting-edge items that are favored by British trendsetters like Kate Moss. Topshop also frequently collaborates with up-and-coming designers, as well as Ms. Moss, to create highly desirable limited-edition collections.

URBANOUTFITTERS.COM—You can always count on UO for of-the-moment designs, styling, and great quality when it comes to shoes, bags, clothing, and accessories.

ZAPPOS.COM—This online shoe and bag store has the largest inventory we've ever seen, ranging from overstock bargain-buys to high-fashion accessories. Their custom search capabilities make it easy to weed through the mass amounts of undesirable product to get to what you want.

ONLINE VINTAGE RETAILERS

ARCHIVEVINTAGE.COM—This site offers designer clothing, shoes, accessories, and home items from the 1960s through 1990s.

EBAY.COM—The king of all resale, eBay allows you to search for specific designers' pieces or general bargains with a few simple strokes on the keyboard.

NASTYGALVINTAGE.COM—We hold this smartly sourced collection of vintage clothing in high esteem. It features mostly anonymous designers, which makes everything extremely well priced. Also, we love that all the pieces are sharply styled on a model, ensuring that you don't even have to use your imagination to wonder how you'd wear that cowl neck cape.

RUBYLANE.COM—If you're in the market for some vintage Bakelite bangles or an eye-catching rhinestone statement necklace from the fifties, visit RubyLane.com.

ONLINE BEAUTY RETAILERS

BLISSWORLD.COM—Beauty mavens are fans of Bliss's amazing body products (including everything from invigorating bath gels to cellulite-banishing creams), now available online. Much like the brand's chain of spas, BlissWorld also offers a range of makeup and hair products, shapewear, and a small selection of clothes, including snuggly cashmere sweaters and flirty frocks.

DRUGSTORE.COM—If you don't have time to run to your local CVS or RiteAid, just stop by Drugstore.com instead. The site offers a huge selection of mass beauty lines, including makeup, hair products, and tools galore.

SEPHORA.COM—Who can resist the beauty mecca Sephora online? Stocked with a huge range of prestige beauty brands, not to mention must-buy limited-edition and exclusive-to-Sephora products, it's a smart stop for any lipstick-loving person.

TARGET.COM—One of our favorite things about Target is their dedication to designer collaborations, a concept that applies to beauty products as well. Check out the insanely well-priced Sonia Kashuk brushes (for face makeup and hair), Soap & Glory (bath products by Bliss founder Marcia Kilgore), and Dr. Bronner's organic soaps.

MAGAZINES

ELLE—One of the top fashion magazines in the world (and our former employer), *Elle* features both big name and breaking designers, photographers, and celebrities. The magazine's coverage and overall tone is a bit younger and more modern than *Vogue*, plus it showcases a mix of price points.

ELLE COLLECTIONS—This thick, image-heavy magazine comes out seasonally (four times per year) and shows the big runway collections from New York, Milan, London, and Paris Fashion Weeks. It's basically a well-documented report of all the upcoming looks and trends; in short: the fashionista's bible.

EUROPEAN VERSIONS—The European fashion magazines (including British *Vogue*, *Elle*, *Harper's Bazaar*, and *Glamour*; *Paris Vogue*; and *Italia Vogue*) always have more inspiring editorials and are worth the higher newsstand prices!

HARPER'S BAZAAR—One of the oldest fashion magazines (its been published since 1867), this glossy is known for showing how to wear a look at any age. Coverage focuses on society and elite trendsetters and the fashion featured is usually in the moderate to high price range.

V MAGAZINE—If you're interested in the most cutting-edge photographers, models, designers, and artists, showcased in stunning layouts, *V* is your magazine. It's the cult magazines for insiders and fans of *Visionaire* (*V* is the monthly version of the limited-edition quarterly *Visionaire*).

VOGUE—The grande dame of fashion magazines, *Vogue* always gets the best exclusives (for everything: stories, products, and coverage) and features them before the other glossies. A must-read.

VOGUE COLLECTIONS—Same as *Elle Collections*, above, but edited by the *Vogue* staff. It's equally good, if not better.

glossary

AU COURANT—A French phrase meaning current or up-to-date.

AVANT-GARDE—A French phrase meaning unorthodox or daring.

BODY-CON—Technically this is just a shortened version of "body-conscious," which refers to fit, usually of a dress. Sometimes also called "bandage style," it just means that the item hugs the body and shows off one's curves.

BOOKS (MAGAZINES)—Another way to say traditional print magazines.

COGNOSCENTI—An Italian word referring to those people who have superior knowledge and understanding of a particular field, especially fine arts, literature, and the world of fashion. In other words: the cool kids.

CONTEMPORARY—Young and modern, usually refers to trend-driven styles.

COUTURIER—The proper name for someone who makes haute couture, which is the highest level of fashion, and offers the most luxurious clothes. These highly skilled people create made-to-measure clothes for the uber wealthy.

DE RIGUEUR—French, meaning "strictly required" and usually referring to a specific standard of etiquette or fashion.

DIRECTIONAL—Another way of saying fashion forward, it means that something is ahead of the trend curve.

DOPPELGANGER—A ghostly double or counterpart of a living person, though, in *Who What Wear* terms, it's the celebrity you most resemble physically. To be used for fashion guidance!

EPAULET—An ornamental shoulder piece worn on uniforms, chiefly by military officers. Most commonly seen on cargo/safari shirts and military-style coats.

FASHION HOUSE—A business that designs, makes, and sells fashionable clothes, typically associated with an important designer. Think: Chanel, Yves Saint Laurent, Gucci, Chloe, Prada . . . you get the picture!

HIGH FASHION—Exclusive and expensive clothing made for an individual customer by a fashion designer. Also refers to the industry that produces exclusive and expensive clothing.

LUREX—A trademark for a plastic-coated metallic thread or fabric made from this material. Basically Lurex gives fabric a little sheen, so it can make an otherwise basic black dress a little fancier.

NATURAL WAIST—The smallest part of one's waist, located between your rib cage and hipbones.

OF-THE-MOMENT—See: au courant.

ON-TREND—In keeping with what is currently popular in fashion.

OPAQUE—Not transparent, translucent, or sheer; rather, it means that a material is dense. We often refer to black tights—the kind you can't see through at all—as "opaques."

ROMEO LOOK—An ill-fated love match that's not meant to be, doomed from the start.

SANS—French, meaning "without."

SILHOUETTE—The outline or general shape of something; a silhouette can refer to clothes or physical figures.

SPANX—A line of body-slimming undergarments.

STATEMENT BELT—A unique belt that catches one's eye because of its size or color; a belt that stands out.

UNSTRUCTURED—Lacking a specific structure or lines; voluminous or slouchy; usually refers to the shape of an article of clothing or a handbag's silhouette.

VOLUMINOUS—Of great volume, size, or extent; think: big poofy skirts.

WELL—The heart of the magazine. The well refers to the key content in the magazine, including the cover-line stories (like the interview with whatever celeb is on the cover) and important fashion spreads.

WELLIES—Short for Wellington boots; a rubber or water-repellent leather boot extending to the knee or somewhat below it.

WHALES' TAILS—A G-string or thong underwear that rises above the waistband of a pair of jeans or trousers. Sightings are less common these days, thanks to low-rise underwear.

photography credits

Aldo (13)

Justin Coit (Cover, 13, 52, 55, 59, 66, 67, 97, 98, 100, 103, 104, 106, 109, 111, 112, 114, 117, 118, 121, 122, 124, 127, 129, 130, 133, 135, 136, 139)

Elizabeth and James (13)

First View (9, 12, 13, 40, 47, 52, 55, 56, 73, 75, 76, 89)

Getty Images (12, 13, 38, 69)

INF Photo (12, 21, 31, 33, 81)

Mel Kadel (12)

Carlos Lopez / Nicole Richie (13)

The Picture Desk (12)

Splash News (Cover, 21, 29, 30, 32, 33, 34, 35, 56, 73, 78, 79, 83)

Richard Stow (12)

Wireimage (13, 21, 31, 75, 76)

X17 (21, 35, 76)

acknowledgments

We are deeply thankful for all the amazing
people who helped us create this book. Whether
they supported us professionally or personally
(or in some cases, both!), their encouragement
and assistance was invaluable. Please know that
you have our eternal gratitude!

Special thanks to Justin Coit, the amazing photographer who shot all of the
What to Wear Where images, for all of his generosity and talent. You helped us
achieve our vision and have contributed so much to *Who What Wear*—we are
lucky to know you.

Additionally, we'd like to recognize all of the people who were instrumental
to this project and our company. We could never have done it without you!
Nelson, Todd Ashley, Kristoff Ball, Brad Beckerman, Stella Berkofsky, Rodger
Berman, Rachel Bilson, Marc Boyan, Jordan Bromley, Alan and Deirdre Coit,
Renata Faiman, Samara Finn, Morgan Flemming, Angela Fink, Ali Froley, Josh
Goldfarb, Michelle Goldstein, Jill Groeber, Norma Gustafson, Rebecca Kaplan,
John and Carole Kerr, John Kenyon, Kenneth Jay Lane, Nina Lenders, Mike
Liotta, Nena Madonia, Pat McGrath, Mika Onishi, Jamie and Kelly Patricof,
Nicole Richie, Monica Rose, Erin Smith, Lisa Storey, Jessie Tettemer, Joseph
Varet, Neil Vogel, Erin Wasson, Kit West, and Rachel Zoe.

Finally, we'd like to send much love and many thanks to our entire staff at
WhoWhatWear.com.

about the authors

Hillary Kerr

Hillary Kerr is the cofounder and Editorial Director of Who What Wear. Prior to the launch of WhoWhatWear.com, she was a Los Angeles-based freelance writer for *Elle*, *Teen Vogue*, and *Nylon*, to name a few. Before starting her freelance career, she was an Associate Editor at *Elle*, where she covered lifestyle, beauty, and pop culture for the magazine. A mix of high (*The New Yorker*) and low (*US Weekly*), she's as passionate about words as she is the other love of her life: her Netflix subscription.

Katherine Power

Katherine Power is the cofounder and Creative Director of Who What Wear. Prior to the launch of WhoWhatWear.com, she was West Coast Editor for both *Elle* and *Ellegirl* magazines. While there, she was responsible for spotting and forecasting emerging trends on the West Coast and translating those trends into both magazines. A mix of high (Christian Louboutin heels) and low (Banana Republic jewelry), she is as passionate about style as she is the other love of her life: her Russian Blue cat, Nelson.

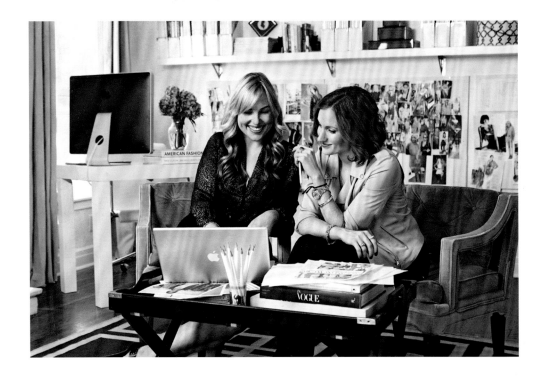

about whowhatwear.com

WhoWhatWear.com is an online magazine with
a subscription-based, daily email newsletter
covering the latest in celebrity fashion, runway
trends, and beauty secrets.

Launched in late 2006, the website quickly
gained a cult following of well-dressed women
around the world, a readership that includes
influential tastemakers, fashion-industry insiders,
and the most stylish celebrities.

In addition to the daily content, WhoWhatWear.com
also offers original programming through style
series such as *Who What Wear TV*, which made
iTunes top video podcast list for 2008, alongside
brands such as Martha Stewart and Oprah.

Editor: Rebecca Kaplan
Designer: Jill Groeber
Production Manager: Jacqueline Poirier

Library of Congress Cataloging-in-Publication Data:

Power, Katherine.
 Who what wear / By Hillary Kerr and Katherine Power.
 p. cm.
 ISBN 978-0-8109-8045-7 (harry n. abrams, inc.)
 1. Fashion design. 2. Fashion—Forecasting. 3. Beauty, Personal. I. Kerr, Hillary. II. Title.

TT507.P69 2009
746.9'2—dc22
2009004651

Copyright © 2009 Hillary Kerr and Katherine Power

Published in 2009 by Abrams Image, an imprint of ABRAMS. All rights reserved. No portion
of this book may be reproduced, stored in a retrieval system, or transmitted in any form or
by any means, mechanical, electronic, photocopying, recording, or otherwise, without written
permission from the publisher.

Printed and bound in China
10 9 8 7 6 5 4 3 2 1

Abrams Image books are available at special discounts when purchased in quantity for
premiums and promotions as well as fundraising or educational use. Special editions can also
be created to specification. For details, contact specialmarkets@abramsbooks.com, or the
address below.

THE ART OF BOOKS SINCE 1949
115 West 18th Street
New York, NY 10011
www.abramsbooks.com